OPENING NEW WOR[...]

DISCUSSIONS ON ART, THEATRE, & LEARNING

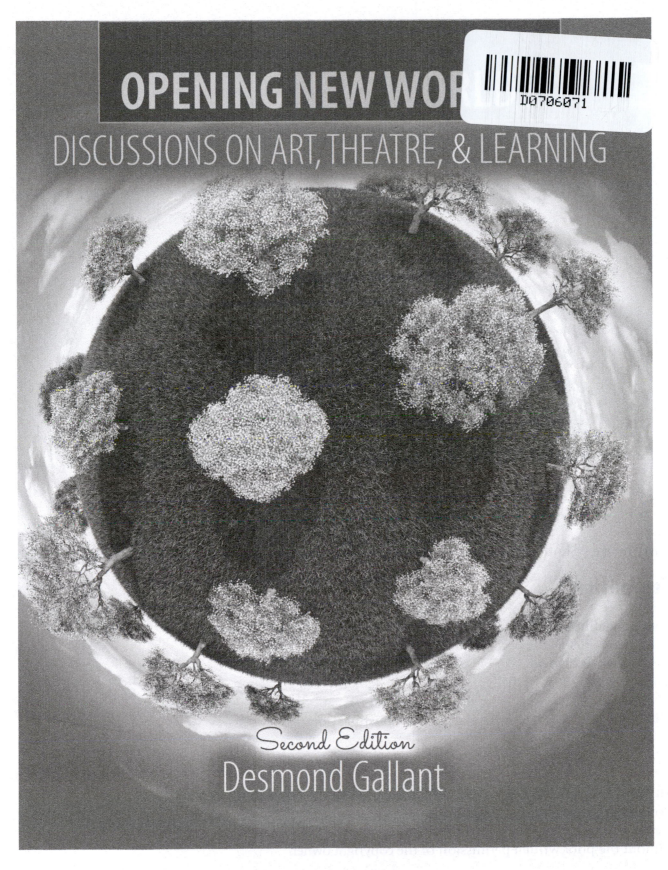

Second Edition

Desmond Gallant

Kendall Hunt
publishing company

Cover image © Shutterstock.com

Kendall Hunt
publishing company

www.kendallhunt.com
Send all inquiries to:
4050 Westmark Drive
Dubuque, IA 52004-1840

Special Thanks to:

Melinda, Braegan, and Danica who make every day
 a joy
Carole and Stephen, who though far away are always
 near at heart
Danielle, who will always be my heart daughter
My father, who will always be remembered
Ryan Schrodt and Leah Schneider at Kendall/Hunt for
 immeasurable patience

Dedication

In Memoriam: Terrence Gallant 1930–1973
Peace

CONTENTS

Introduction

I believe that the introductory theatre class, Appreciation of Theatre, is one of the most important classes I teach. We are all familiar with the expression "preaching to the choir" which is exactly what I do with the graduate acting classes or the directing classes I teach. The students in those classes need no reminding of the important role theatre has played in their lives. No, it is to those students who aren't in the choir, to those who form the majority of the introductory classes that we must reach. Reaching non-theatre students and awakening them to the true purpose and importance of the theatre is what makes this class one of the most important.

Now that being said, it has always been my belief that fundamental to the appreciation of the theatre is an appreciation of the arts and an appreciation of learning as well. As such, after a year or so of teaching the class, I began to assign supplementary readings that were not found in the assigned textbook—readings that addressed topics not usually found in standard theatre textbooks.

As we discussed these readings in class, I would regularly reiterate my belief that learning is a never-ending process; a process that should for all students continue well beyond their college years. And I would discuss my own ongoing learning. While fulfilling my teaching duties and directing productions for the department, I also made sure that I continued to read and re-read books with a focus on creating theatre, the practice of education (both teaching and learning), mind development, and the purpose of the arts. These books began to play an even more significant role in my teaching and my thinking.

As the semesters at the university passed by, it became increasingly clear to me that each year's freshmen were not all uniformly prepared for the academic challenges they would face at the university. For many, organizational skills, time management skills, and good study habits had not been learned. Many arrived unprepared for the demands placed upon them by a full load of college courses. And students were arriving this way because most of our high schools are simply not adequately preparing students for college.

In the current climate, schools have been forced to spend so much time preparing their students for state-mandated assessment tests that they aren't preparing their students for the aspects of education that really matter: independent, critical thinking; the skilled use of imagination; the courage to formulate and voice one's own opinion; fundamental communication skills, both written and oral; and an appreciation that learning is about a journey and not about a result. In fact, most students believe that the true purpose of their education is career preparation, a belief that is reinforced by much of society. Instead, what education should really be about is life preparation, which includes preparing for a career—but a career that must and will occur in a social environment that requires life skills.

For a myriad of reasons, many of which are addressed in this book, many students do not know what learning truly involves. They don't realize that education will necessarily involve hard work; that it is not entertainment; that it requires effort outside of class time; and that, ideally, they should spend more time doing homework than engaging with social media or other forms of entertainment. Many students have come to believe that education is based on someone—the teacher—feeding them "factlets" and correct answers and their then subsequent regurgitation of what they've been fed. They have come to believe that if "it is on the test" it is important; anything else is superfluous and not worth the effort. Students need to be disabused of these ideas. Students should be encouraged to understand that what education is really about is hard work, discipline, and the *joy* inherent in *actual learning*.

These truths have led me to believe that universities would do well by their students if they offered and required all first-year students to take at least one class in college preparedness and

appreciation of learning. If such a class were offered in the very first semester, it is my belief that the number of students who get off on the wrong foot or who drop out early would decrease. This class, while it would not be a panacea, would be of great benefit to all incoming students, especially to those who are eager for college and who are enthusiastic about their education.

In the absence of such a class, however, I've begun to address some of these issues and bring student attention to them. I do so while taking care not to override the true focus of the class: the appreciation of theatre.

Artists and arts educators have increasingly been asked to explain and defend what it is they do, why they do it, and why the arts are important. This necessarily means that part of my job as an arts educator is to share with the students in my classes the importance of the arts. My job as theatre professor teaching theatre appreciation cannot be accomplished without also teaching an appreciation of the arts, and this means dispelling certain myths about the arts and awakening students to their true purpose—their important purpose.

In the United States today, neither the arts nor education are funded as adequately as they should be, and neither is held in as high esteem as they once were. Arts education has been hit doubly hard. The removal of the arts from the curriculum has come about for four specific reasons. The first is because of a shift in the American understanding of the purpose of education; an understanding that has seen a focal shift from learning to career preparation. With this shift, any discipline that is not seen to be directly related to career preparation is deemed superfluous. This view has led to the second reason for cutting the arts, which is that as governments try to create accountability in schools, which they view as ensuring students' preparation for the workforce, schools are pressured into cutting all subjects and activities not directly related to the criteria and subject matter of state-mandated assessment tests. A third reason for the removal of the arts from the curriculum is the fear that some pockets of society have of the arts—the fear that the arts are subversive, morally corrupt, and therefore dangerous. While it is true that artists often challenge the status quo and that works of art often ask society to assess itself critically, these are healthy practices. A healthy democracy continually challenges itself to rethink and re-examine its most fundamentally held precepts. Examples abound of artists creating works that have raised society's awareness of injustices and that have then been instrumental in bringing about social change. The fourth reason for the removal of the arts from the curriculum is based on the general public's association of the arts with frivolous pursuits and the subsequent ignorance of their educational importance. But the arts are neither frivolous nor dangerous. They are disciplines that develop minds and grow intellects.

Increasing numbers of studies are showing just how shortsighted and detrimental the removal of the arts from the curriculum has been. All students have suffered because of it, not just those who wish to pursue a career in the arts. The arts teach students fundamentals needed for more advanced study and for success in everyday career life. It is not unrelated that as public schools have cut the arts and focused on state-mandated assessment tests, *actual* reading, writing, and comprehension skills in first-year college students have decreased. The simple fact is that many students cannot write, and though certainly their knowledge of grammar, spelling, and syntax has suffered, it is their ability to comprehend and formulate clearly structured thought that has really suffered.

Another unfortunate result of the elimination of arts programs in schools has been the creation of the "magnet school." The magnet model now permeates not just the high school level but also the middle and primary levels as well. This trend is the exact opposite of what should be happening. A well-rounded education means that all students should be exposed to all subjects and specialization shouldn't occur until much later in a student's education. A child in the third grade should not be so narrowly focused; it is a dangerous mistake.

Jane M. Healy, in her book *Endangered Minds: Why Children Don't Think—and What We Can Do about It*[1], says "what children do every day, the ways in which they think and respond to the world, what they learn, and the stimuli to which they decide to pay attention—shapes their brains. Not only does it change the ways in which the brain is used (*functional change*), but it also causes physical alterations (*structural change*) in neural wiring systems" (Healy, 1990, pp. 50–51). If the stimuli introduced into a child's brain shape it functionally and physically, we need to make sure that all students are exposed to all forms of thinking and cognitive processing. If we are truly concerned with preparing students for their future careers, we need to ensure that they all are equipped with the tools that will allow them to confront, assess, and solve all of the myriad situations and conditions they will encounter throughout their educational and post-educational lives. This necessarily means that we need to expose students to curriculum and activities that encourage and develop divergent thinking as the arts do. They need to study these subjects as well as subjects such as mathematics and science that rely more heavily on convergent thinking.

Since the arts develop analytical, critical, and divergent thinking; since they develop the imagination; since they are a means of communication that allow individuals to learn about humanity, the world, and themselves; and since they encourage students to develop the confidence to formulate their own opinions and express those opinions; it is significant then, that the arts magnet schools tend to be some of the best schools and that the students attending these schools very often outperform their non-arts-magnet peers in all disciplines including those that are not arts related. So much so, that now many parents who have no particular intention of encouraging an arts career for their children are trying to get their children into an arts magnet school anyway.

We must rethink our understanding of education and place its focus back on learning if we are to properly prepare our students to compete globally, and that means learning must include the study of all subjects for all students. Once the public comes to understand this, the arts will again find their rightful place in our schools' curriculum. Until that happens, our students will continue to be denied the high-quality, comprehensive education they deserve.

It is, therefore, my hope that this short book will serve a specific purpose for those students currently enrolled in introductory theatre courses—that with it, we will take a small step toward reaffirming the importance of the arts and the theatre; that we will increase public appreciation of both; that we will embrace learning and education; and that we will include the arts as a fundamental component of a holistic approach to education. It is also my intent that with added chapters in future editions, this will become a book that will prove equally appropriate for all introductory arts classes—those in theatre, music, dance, and the visual arts.

This book is for all students who hope to succeed in college, those who hope to succeed in life, and those who hope to see the world as something bigger and more significant than just themselves.

[1]Healey, Jane M. *Endangered Minds: Why Children Don't Think—and What We Can Do about It.* New York: Touchstone, 1990.

C H A P T E R 1

Welcome to the College Experience

ENJOYING THE RIDE: A BEGINNER'S GUIDE TO ENJOYING YOUR EDUCATION *by Desmond Gallant*

Introduction

In this short article, the author discusses the common notion that life and education are journeys, and he notes ways in which individuals choose to make their journeys more rewarding through active engagement, hard work, commitment to excellence, and enthusiasm. In a time when many students seek out the shortest, easiest path, the one that requires the least amount of effort and that sometimes employs shortcuts with dubious ethical standards, the author reminds us that in order to achieve an honest sense of satisfaction, one must exercise effort. The article argues that self-esteem and self-confidence in students are achieved through sustained work and the effort applied to solving difficult tasks.

He also discusses the fact that for most first-year students, the beginning of college marks a new start and the first leg of an individual's journey into adulthood with new independence and responsibilities, and that, by the end of our college years, we are expected to begin life as an independent adult. What this means, then, is that we must use our college experience to become fully prepared for adult life, which necessarily includes an increased awareness of ourselves and of the world around us if we are to be successful and satisfied. It requires a comprehensive educational experience to achieve this, and that comprehensive educational experience includes not only a wide variety of subjects to be studied, but also must include extracurricular activities as well.

Finally, the author addresses the idea that the type of experience we have is ultimately one of choice, and that we ourselves are solely responsible for our choices. He says that, more often than not, typical experience descriptors such as "boring" and "uninteresting" are choices that we ourselves make and that they have little or nothing to do with the external factors contributing to our experiences.

Every morning at kitchen tables, on buses, trains, and subways across the country and, indeed, the world over, millions of people pick up their newspapers, turn to the crossword puzzle and begin to try to solve a series of mysteries with a number of given clues. While many of these people do not successfully complete their puzzles, leaving certain words blank or having filled them in incorrectly, day after day they continue to engage in the activity anyway. Why? Because the enjoyment derived from completing a crossword puzzle does not lie in the completed puzzle but in the process of solving the clues. It is the journey and not the destination that excites. This is true of all puzzles, mysteries, and riddles, and it is also true of life itself.

The completed puzzle that lies at the end of life is death. It is safe to say that, with very few exceptions, most of us do not live our lives eagerly anticipating death's arrival. Some of us may have views of the afterlife that would seem to offer their own rewards, but that does not necessarily mean we want life to end now in favor of the afterlife. In fact, most people, I think it is safe to argue, are prepared to delay the afterlife in favor of the current one being lived. This is because, as trying as life may be at times, the uncertainty of death fills many with fear, but also because, for most of us, *living* life, even with all of its ups and downs, is the reward—especially if it is a life lived *with purpose*. There is no avoiding death—that's obvious; it is the only certainty in life and it will come soon enough. So what should our purpose in life be? For people of faith, should it be to live in anticipation of the afterlife? For agnostics and atheists, should it be to live in fear of death? Or is there something much more important for us all to do? Ask yourself: What am I expected to make of my life? What purpose is my life to serve?

I'd like to suggest you think of your life as a cross between a crossword puzzle and a rollercoaster; the thrill of both is not in the destination, but in the ride. It is much like watching or reading a murder mystery. Our task is to be fully engaged in figuring out who is who and what is what and how we fit into the whole. The best mysteries are the ones that keep you guessing and those that have unexpected twists. Much of life's pleasure is derived from trying to solve its inherent, eternal mysteries, as well as those smaller-scale mysteries we encounter on our own individual paths every day.

What has all of this to do with your college experience? I would like to suggest that regardless of whether or not you've decided on a career path and what course of study you're pursuing, you should still think of your education as a journey—just one of the many that will form the larger journey of your life. I'd also like to suggest that you view this journey as a rollercoaster ride that you should relish with élan in your heart. Throw your arms up in the air and scream out in glee. Embrace your education with the same alacrity you would life; for there are wonders to discover and insights to be gained.

In her book *Wolves & Honey: A Hidden History of the Natural World*, Susan Brind Morrow discusses an interview technique of naturalist and Harvard professor Louis Agassiz. When a prospective student would apply to study under Agassiz, the naturalist would "set before [the student] a fish preserved in formaldehyde. He would leave the [student] alone there for hours with the instruction, 'Look at your fish'"(Morrow, 2004, p. 117). The implication was that Agassiz would study the prospective student to see how much curiosity, love of learning, and love of subject the student displayed. How much curiosity do you have? How much joy do you take in discovering life? We all enter this world as babies open to discovery. Young children begin each day reinvigorated and excited about learning. As young children, learning and discovering are pleasurable. For some, that pleasure is never lost; for some, it is lost and then rediscovered; for others still, it is lost and then never found. For those in the latter group, life becomes tedious, a chore to be endured, and more often than not, they are those who, on their deathbeds, are rife with regret for what was not discovered and celebrated. If you've lost your curiosity, your joy of discovery, if you feel bored,

uncommitted, or uninvolved, change! Rediscover the joy of discovering the world and learn to love to learn again!

But also remember that learning is hard work. It requires effort. Anything worth doing requires effort. This is why those who work hard at a task always find the experience and completion of the task more rewarding. Those who choose to complete crossword puzzles always feel a greater sense of accomplishment when they attempt a puzzle that is challenging. How much more exhilarated is the athlete whose success is achieved next to a strong opponent. The easy knock-off isn't nearly as rewarding. The same can be said of drama. A film or play with equally matched opponents creates greater conflict and therefore a more rewarding experience. When studying self-esteem in children, it was found that acquiring true self-esteem required hard work and dedicated application to the completion of a task.

> [W]hat increases children's self-esteem is precisely the sustained work that is often necessary to accomplish anything difficult. Children know when they have worked hard, and when they have learned to do something well. That is what develops real self-confidence. (Light, 2001, pp. 19–20)

Most professional athletes and professional musicians know this. In order for both to succeed, talent alone isn't enough; each must also practice and practice and practice. It is only the exceptionally rare individual for whom talent alone might be enough, but even for these, one can only imagine just how good they could be if they also invested sustained effort.

This is true for everyone; to be truly successful in life, one must work hard at developing oneself. We live in a fast-food culture where we expect everything to come easy, fast, and cheap. The truth is that education is not cheap, easy, or fast. Life is not cheap, easy, or fast. Successful individuals understand this, as do successful corporations. For those individuals who become accustomed to employing fraudulent means to achieve success, inevitably at some point, they are found out and suffer disgrace. They may ride high for awhile but eventually they pay the price.

For most first-year college students, those who are newly out of high school, the university experience is an initiation into adulthood; it marks the beginning of true independence. When you have completed your college years, you will be expected to either continue your education seeking out higher degrees with more advanced learning, or to use your newly acquired knowledge and seek out employment. In either case, you will be leaving college with more independence and greater responsibilities than when you arrived. Being prepared for life after college will also require that you develop a greater awareness of yourself, of those around you, and of the world as a whole. It is for this reason that you avail yourself to a world of discovery and that you not spend your college years focused solely on the goal of achieving a *piece of paper* by journey's end. As already stated, the true purpose of your education and your life is your complete engagement in the journey.

Engaging in the journey means getting involved in your own education and it means participating in activities outside of the classroom. These can be extracurricular such as sports, arts events, organized social groups, volunteerism, etc. It means opening yourself up to new experiences, exploring new ideas, new subjects, seeking out knowledge for the sake of knowledge itself. You have a choice, your college experience can be a chore, something you have to do because you are told you must, or it can be a celebration, something you relish and embrace. It is your choice. No one but you controls your experience. You alone make the choice to make your experience a rewarding one or a disappointing one. Remember it is your choice—yours alone.

Learn for the sake of learning, gain knowledge for the sake of gaining knowledge, think for the sake of thinking, feel for the sake of feeling, enrich yourself for the sake of becoming enriched. Do these things and you will enjoy your ride; do the other and when you arrive at the end of the ride, you will turn around and wonder why everyone else is smiling and laughing, why they all seem to be so exhilarated and you are frustrated and bored. If you find yourself identifying aspects of your education as "boring," rethink your attitude toward education. Whoever said education was meant to be entertaining? Education is not entertainment. That is a great fallacy; a fallacy perpetuated by "educational television." No, more often than not, the responsibility for being bored falls squarely on the shoulders of he who is bored. More often than not, boredom is a choice; a choice each individual makes for himself.

A final analogy: For years I worked at a horror house and always we had two types of customers who ventured through the creepy hallways. There were those who upon entering decided that they would jump in heart first and thrill themselves with the experience. And then there were those who needed to prove that nothing could scare them. We all, but for the youngest of children, know when walking into a horror house that what we see and hear is not real; however, for the sake of having a good time, we decide to *believe it to be real*. It is those who *choose* to believe it to be real who walk out, heart racing, blood pumping, breath fanning, faces grinning, eyes wide—alive as alive can be! Be alive in all that you do. Be alive in your life! Be alive in your studies! It is your choice—yours alone. And it *is* a choice.

WORKS CITED

Light, Richard J. *Making the Most of College.* Cambridge: Harvard University Press, 2001.

Morrow, Susan Brind. *Wolves & Honey: A Hidden History of the Natural World.* New York: Houghton Mifflin, 2004.

Name _____

ENJOYING THE RIDE: A BEGINNER'S GUIDE TO ENJOYING YOUR EDUCATION *by Desmond Gallant*

Review Questions

1. In the article, the author says "Much of life's pleasure is derived from trying to solve its inherent, eternal mysteries, as well as those smaller-scale mysteries we encounter on our own individual paths every day." What would you say are some of those "inherent, eternal mysteries" to which the author is referring? What do you think are some of the "smaller-scale mysteries" to which he is referring?

2. If, as a college student, you are required to take certain courses as part of a core curriculum, some of which may not be related to your major or even your interests, how do you suppose the author reconciles that with the belief that no one but you controls your experience and that you alone choose to make your experience a rewarding one or a disappointing one? In other words, discuss how it is that you can choose to make your experience in a course whose subject matter does not speak to your interests a rewarding one. Discuss how it is that you can choose to make your experience in a course a disappointing one.

3. If you had to divide up responsibility for your educational experience into percentages, what percentages would you give to the following groups or individuals? Then defend your choices.

a. The college administration

b. Your parents or legal guardians

c. Yourself

d. Your professors

e. Your friends

f. Others

4. In the article, the author states that living a life invested with purpose renders one's life more rewarding. In a page or two, discuss what it means to live a life invested with purpose. In a page or two, describe and discuss what purpose you have in your life.

5. In the article, among the extracurricular activities the author discusses, he mentions volunteerism. How do you suppose volunteering can make your college experience a more rewarding one? How might it enrich your life?

Research Topics

1. The article references the author Susan Brind Morrow. Who is she? What is her book *Wolves & Honey: A Hidden History of the Natural World* about?

2. The article, in quoting Susan Brind Morrow, references Louis Agassiz. Who was he? What is notable about the work he did?

3. If there is one nearby, take a trip to a horror house or some other similar attraction and give it a go. Do it for the fun of it and make sure you "buy into" the experience. Make it a fun activity for you and anyone else who may be with you.

4. In the article, among the extracurricular activities the author discusses, he mentions volunteerism. Seek out an opportunity to volunteer once a month or once a week and do it. After four such sessions, write down in a page or two how the experience has changed or enriched your life.

JUSTICE OR JUST US? WHAT TO DO ABOUT CHEATING *by Jason Stephens*

Introduction

This article is an excerpt from the book *Educating Citizens: Preparing America's Undergraduates for Lives of Moral and Civic Responsibility* by Anne Colby, Thomas Ehrlich, Elizabeth Beaumont, and Jason Stephens. The title of the book itself is very telling—by that I mean that the very fact that the book had to be written at all tells us something about an aspect of education that is all too often ignored. People do not have an innate sense of moral and civic responsibility; it, like everything else, needs to be learned and—*taught*.

In this article, Jason Stephens focuses on cheating as just one small aspect of a student's moral responsibility. He briefly addresses the types of behavior students understand as cheating and the reasons why they might engage in such behaviors. He also discusses why cheating robs students of the most important function of their education and how it adversely affects their preparedness for their careers and their ability to function in working social environments.

While in essence the article is written with educators in mind, it is still of great value to students because it allows them to examine and analyze their own perceptions of cheating, and provides them with insight into how cheating will affect their university and post-university experiences.

Earlier this year, local papers were full of horrified reports of cheating in an affluent Silicon Valley high school. Stories like this are a regular occurrence. Last year cheating at the University of Virginia made headlines, and before that, it was the military academies.

Adults always seem shocked and surprised to learn of cheating, especially in high-achieving and high-socioeconomic settings. They shouldn't be so surprised. Research on cheating has shown over and over that most students do cheat, at least some of the time. Research in high schools shows that two thirds of students cheat on tests, and 90 percent cheat on homework. The figures are almost as high among college students. Furthermore, it is clear that rates of cheating have gone up over the past three decades.

Why? Do students fail to understand that cheating is wrong? Well, yes and no. In a recent study of high school students that I conducted, many students acknowledged that cheating is wrong but admitted they do it anyway, seemingly without much remorse. Jane, a tenth-grade honors student, is typical of these students:

Like people have morals, they don't always go by them. . . . So I mean, even if you get that test and you're like, "Oh yeah, I cheated on this test," It doesn't lessen that grade. It says an A on the paper and you don't go, "Oh, but I cheated." You're just kind of like, "Hey, I got that A." So it doesn't really matter necessarily, if it has to do with your morals or anything, you just kind of do it.

Like Jane, other students in the study said that they cheat for simple, pragmatic reasons—to get high grades and because they don't have time to do the work carefully. Especially for college-bound students, the pressure for grades is real. According to the Higher Education Research Institute's annual survey, 47 percent of incoming college freshmen in 2003 reported having earned an A average in high school. As Jane put it:

It's not always necessary (to cheat). I guess if you already have straight A's, then why cheat? But yet, we still seem to do it. It's kind of like insurance, like you feel better, you feel safer, if you do it. . . . Then I will have that 95 instead of like the 90, because that's almost like a B or something.

But despite the pressure for consistently high grades, students don't generally cheat in all of their classes. And somewhat surprisingly, it is not the difficulty of the course that predicts in which classes they are more likely to cheat. Instead, I found that high school students cheat more when they see the teacher as less fair and caring and when their motivation in the course is more focused on grades and less on learning and understanding. At least in these classes, they can justify cheating. They don't claim it is morally acceptable, but they don't seem to feel that it really matters if they cheat under these circumstances.

In most studies of cheating, the researcher decides which behaviors constitute cheating, and students are only asked to report how often they engage in those behaviors. In my survey of high school students, I asked them to report both their level of engagement in a set of 12 "academic behaviors," as well as their beliefs concerning whether or not those behaviors were "cheating." Not surprisingly, the vast majority (85 percent or more) indicated that behaviors such as "copying from another student during a test" and "using banned crib notes or cheat sheets during a test" were cheating. However, only 18 percent believed that "working on an assignment with other students when the teacher asked for individual work" was cheating. Subsequent interviews with a small sub-sample of these students revealed that students regarded this forbidden collaboration as furthering their knowledge and understanding, and therefore saw it as an act of learning rather than a form of cheating. These findings suggest that students make a distinction between behaviors that are overtly dishonest (such as copying the work of another, which effectively serves to misrepresent one's state of knowledge) and behaviors that are not inherently dishonest (such as working with others, which can serve to enrich one's interpersonal skills and academic learning). Educators, too, should be cognizant of this distinction and be judicious in prohibiting collaboration.

With this pervasiveness of acceptance by students, is it acceptable to us as a society to tacitly accept cheating as a fact of life and not be so shocked when it comes to light? I don't think so. Cutting corners and compromising principles are habit-forming. They don't stop at graduation, as we have seen in recent scandals in business and journalism. And cheating or cutting corners in one's professional or personal life can cause real damage—both to oneself and to others. We need to care about it.

And I believe we can do something about it. The best ways to reduce cheating are all about good teaching. In fact, if efforts to deal with cheating don't emerge from efforts to educate, they won't work—at least not when vigilance is reduced. These suggestions are easier said than done, but I believe they point in the right direction, both for academic integrity and for learning more generally.

- Help students understand the value of what they're being asked to learn by creating learning experiences that connect with their interests and have real-world relevance.

- Consider whether some of the rules that are frequently broken are arbitrary or unnecessarily constraining. For example, is individual effort on homework always so important? Given the evidence that collaboration in doing homework supports learning, it doesn't seem so.

- As much as possible, connect assessment integrally with learning. Create assessments that are fair and meaningful representations of what students should have learned. Make sure assessments provide informative feedback and thus contribute to improved performance. When possible, individualize evaluations of students' progress and offer them privately. Avoid practices that invite social comparisons of performance.

- Give students images of people who don't cut corners: scientists who discover things they don't expect because they approach their work with an impeccable respect for truth and a genuinely open mind; business people who exemplify integrity even when it seems like it might cost them something. But don't preach. Take seriously the fact that, in some contexts, being consistently honest can be hard.

Finally, as educators, we must do our best to exemplify intellectual integrity ourselves—in everything from how we treat students and each other to how we approach the subject matter, to how we approach mandatory high stakes testing to how we think and talk about politics. We need to look for ways to make deep and searching honesty both palpable and attractive.

Name _____

JUSTICE OR JUST US? WHAT TO DO ABOUT CHEATING *by Jason Stephens*

Review Questions

1. Think back to your recent high school experience and ask yourself honestly if you had ever engaged in behavior that you would now consider cheating. At that time, did you also think of it as cheating? If you did, why did you engage in such behavior despite knowing it was wrong? Would you do so still?

2. Consider the value of a university degree and all that it means to a prospective employer about your achievements, knowledge, and preparedness. Does cheating affect the value of a university degree?

3. Would you say we live in a society that tolerates, encourages, or discourages cheating? Why? Can you offer any examples to support your opinion? Can you offer examples that dispute your opinion?

4. Can you give three reasons why cheating is not a good idea? Can you say specifically what makes it wrong?

5. In the article, the author says that he found that high school students tended to cheat more when they saw the teacher as less fair and caring and when their motivation was more focused on grades and less on learning and understanding. What, in your opinion, constitutes a "less fair and caring" teacher, and does that justify cheating? What can you do to ensure your focus remains more on learning and understanding than achieving good grades? Can you see that there are more benefits to achieving your "good grades" through learning and understanding than through cheating?

6. In the article, the author offers a few suggestions that will help encourage academic integrity. What are they?

7. In one of the suggestions for encouraging academic integrity, the author says, "in some contexts, being consistently honest is hard." What do you suppose are some of those contexts? Why do you think being consistently honest is so hard?

Research Topics

1. Research examples of people outside of college who have cheated in their professional lives. Are there examples in journalism, politics, sports, business, medicine?

2. Seek out someone who earned his degree several years ago and ask him if he ever cheated and, if he had, ask him why and whether he would reconsider cheating if he had the chance to do it over again.

ARE YOU PREPARED? *by Desmond Gallant*

Introduction

In this article, the author discusses issues of preparedness for college. He addresses time management, increased workload, and organization, as well as the greater expectations students will encounter while at college. He goes on to suggest ways students might learn to cope with the increased expectations and offers tools they might employ to help themselves succeed. Also addressed is the fact that, for most first-year students, the beginning of college marks a new start with an increased focus on independence and responsibility, and the author offers suggestions on how to handle the increased independence.

The article identifies certain traps, pitfalls, and mistakes new college students often make and offers suggestions about how a student might avoid them. These include certain erroneous beliefs common among first-year students about essay and paper writing and the research done in support of them, and certain misconceptions about extracurricular time commitments and their relationship to grades.

The article also addresses the issue of excellence and discusses how students can bring excellence into their work and their lives, and how to be sure to exercise it consistently.

Finally, the article discusses the very idea of learning and what learning truly consists of. It addresses the idea that learning doesn't stop once a student leaves college but, rather, it continues throughout an individual's life. In its examination of the process of learning, the article discusses certain skills needed for a comprehensive learning experience, and argues that those same skills are those required of individuals in their careers.

A FRESH START; A NEW WORLD

Probably one of the biggest challenges new college students face is preparedness. New college students, whether brand new first-semester freshmen or more seasoned second-semester sophomores, will or have encountered a very different environment with much higher expectations than they were accustomed to in high school, and if certain key adjustments are not made early on, the first year or two can be overwhelming and even distressing and can mean the difference between early academic success or failure.

During the very first few days and weeks most students run on adrenaline as they are consumed with getting their affairs in order—registering for classes, buying books, settling financial matters, finding classrooms, and encountering new friends and acquaintances. As these details are worked out and then later as the students continue to adjust to their new surroundings, there are important things they should keep in mind as they adapt to their new world.

As all new students soon discover, college is, in fact, a completely different world than what most had grown accustomed to in high school. College campuses typically are much larger, the administrations are much more complex, the classroom experience is much more varied, the daily schedule is much more loosely structured, supervision is virtually nonexistent, and most importantly, the workload is much heavier. At college, all students are immediately expected to manage their own affairs and exercise a much greater degree of self-discipline. Unfortunately, however, many students are not prepared for the increased independence and the amount of freedom that independence affords them, and some may not have yet developed the maturity necessary to cope with such an unrestricted atmosphere. This often results in failed classes, poorer grades overall, dissatisfaction and disillusionment, and, if allowed to continue unchecked without proper intervention, academic probation and possibly dropping out altogether.

To avoid this, ideally, each new student would be well served to take a course or two preparing them for the new demands and expectations of college life. This is something, however, that few universities and community colleges provide. As

such, you, as a new student, will need to learn how to function successfully in an environment that places few restrictions and offers little supervision. Your level of maturity will be greatly tested. This means caution should be exercised as temptations will be many and not all paths lead to the same destination. You will need an increased awareness of all of the possible consequences that will result from all choices made. It is perhaps advisable, then, to take college life slowly at first and to make sure you acclimatize before exploiting the newfound freedoms. Be wise and don't rush into anything.

This may sound like the proverbial cautionary words from parents and grandparents and they may make you want to shut out the warnings they contain, but know that, year after year, students just like you make simple mistakes that are easily avoidable. Not a year goes by when I don't hear a student lament the fact that they have an extra semester or two or three to make up because they screwed up some of their early classes—classes they say they failed either because of foolishness and immaturity or because of a lack of preparedness.

As Anthony Wilson-Smith suggests in his article "The Freedom to Choose," the beginning of your university life is, in fact, a new start. College is the new stomping ground where everyone needs to prove her or his mettle again. It is where everyone gets to start fresh and the promise of success is not based on past accomplishments but on the effort and discipline applied in the here and now. This means that you too, with your arrival at college, can start your academic slate again. You can build on your successes from high school and wipe away the mistakes. You can take the steps to make sure your start and finish (and everything in between) at college is all success. Or, on the other hand, you could become one of those seniors in their fifth or even sixth year at college making up for early mistakes; or one of those graduates who has to explain to a job interviewer that the reason you have those six "Fs" and three "Ds" is because of the lack of maturity you exhibited early on at school.

Now with that all said, before you know it, your time at university will be over and you will have your degree. You'll then need to decide what to do with that degree. For those who choose to enter the workforce you will want to make sure that you are prepared for your career. For those of you who decide to go on and get an advanced degree, you'll want to make sure you are prepared for advanced studies. What does that mean? Well, you can be sure that just having the piece of paper with your degree title printed on it is not enough if you don't have the knowledge to support it. However, in addition to the actual knowledge you've gained, there are other qualities you'll need to possess in order to enjoy a successful post-undergraduate life. These are, as Charles Fowler points out in his book *Strong Arts, Strong Schools*, the keys to post-undergraduate success, because they are the qualities that businesses across the country are looking for. You will need to demonstrate a sense of responsibility, self-discipline, pride, teamwork, enthusiasm, and the ability to learn, solve problems, and communicate well (Fowler, 1996, p. 21).

These qualities are crucial and they are the very qualities you'll want to make sure you are developing and refining while pursuing your studies. Perhaps the most deceiving of the qualities listed above is the ability to learn. This is because one might argue that obviously if one completed one's studies and garnered a degree, one knows how to learn. But one must be cautious about this assumption. Many people are able to complete their studies by mastering the skill of memorizing facts and information, and then regurgitating those facts as necessary while never really developing the skills needed to actually learn. Learning in a comprehensive way requires the ability to think both convergently and divergently, as explained later in this article. It also requires certain skills that will continue to come in handy after you've graduated—throughout your career life and beyond.

Therefore, you need to approach your education as more than just learning facts fed to you by someone else. You need to learn how to learn, how to problem solve, how to think critically and independently, and how to actively engage your imagination. For those of you whose high school experience included state-administered assessment tests, tests that meant much of your classroom experience involved preparing and studying for those very tests, which also then necessarily meant that you learned how to absorb what you needed for the test and how to simply recite it back, the previously listed skills may not have been learned nor exercised adequately. The "test prep" approach to education, an approach that is symptomatic of a fast-food culture that looks for quick, simple, and cheap ways of accomplishing something, is not an approach that properly prepares students for the type of thinking and learning that is necessary for

true academic and career success. As the "test prep" approach to education has increasingly become the predominant approach, it is no surprise that many professors report encountering an increasing number of students who demonstrate interest solely in information they are told "will be on the test." Our education system has created students who believe that anything not "on the test" is superfluous. Be aware if you hold this belief system; if you do, break out of it. It is a trap. True learning moves beyond what is on the test. True learning is experiential and participatory.

To reinforce this point, it has been suggested that there are "seven autonomous intelligences: linguistic, logical-mathematical, musical, spatial, kinesthetic, and two forms of personal intelligence—interpersonal (understanding other people) and intrapersonal (understanding yourself)" (Fowler, 1996, p. 40). If this is true, there is not a test created that can measure all seven of these intelligences, not to mention whether or not an individual is developing and growing in each. Given the narrowing scope of the curriculum in our educational systems, we can be assured that these separate intelligences are not all being developed adequately. In fact, many are being seriously neglected and this is now exacerbated by the excess emphasis placed on assessment tests. This becomes especially true when the tests are used to measure the success of the teacher and the school, which then of course almost ensures an overemphasis of time spent "studying for the test" at the expense of all other forms of education and learning. This then means that you yourself, as an independent adult student, now must make the effort to develop and exercise those intelligences that you feel may have been neglected. Some methods for this are addressed later in this article and elsewhere in this book.

LEARNING THE ENVIRONMENT; BEING INDEPENDENT

As you start your college life, make an effort to discover all that your university has to offer you. Discover all of the things it has to make your education and experience more rewarding, successful, and fulfilling. Take the first few weeks to learn about what educational and social support is available to you. You may at some point need to take advantage of these; I'll discuss some of these in more detail later. As stated earlier, the university experience is about being independent

and developing greater maturity. It means truly becoming adult. Mature adults learn to seek out and accept help when they need it, to ask questions if they don't understand something, and to address issues soon after they arise. As an independent adult in college, you want to be in control of your life and education, and that means that you don't wait to be lead but you lead; you aren't apathetic but involved; you aren't passive but self-motivated.

Making the most of your education will require active participation in your educational experience. This means fully engaging in all of your classroom experiences, participating in social activities, studying with friends and classmates, and so on. Students who do not do this suffer academically.

> There are two other symptoms that . . . may well be predictive of troubling outcomes. [One is] a sense of isolation from the rest of the college community . . . [and the other] is unwillingness to seek help . . . Of the twenty students who were struggling yet were able to share their problems and to seek help . . . all, *without exception*, were able to work at strategies to improve their academic performance. But most of the twenty who were unable to share their problems remained distressingly isolated. They became caught in a downward spiral of poor grades and lack of engagement with other people at the college. It was harder for them, struggling alone, to turn their situation around (Light, 2001, pp. 35–36).

If you are to succeed to the best of your abilities, you will need to be acquainted with all of the resources available to you and you will need to take advantage of them as necessary. These include your professors, all of whom want to see you succeed; the university's academic advisors; the university's social counselors; peer support groups; fraternities and sororities; librarians who are available to teach you the ins and outs of using the library; athletic clubs; and the university's writing resource center, among others. Many of these are discussed in more detail in the following paragraphs.

GREATER EXPECTATIONS: CRITICAL THINKING, WRITING, RESEARCH, AND PUNCTUALITY

Be aware, now that you are at college, that the expectations placed upon you will be much higher than those that were placed upon you at high

school. This means that, for many of you, the caliber of work you've been producing at high school will not suffice any longer; you will need to bring your work up to the next level. Along with your greater maturity, your professors are going to expect your work to reflect higher academic standards. They are going to expect you to demonstrate a greater degree of critical thinking. This will be important since, in one study, it has been pointed out that most students who were found to be struggling academically indicated that the ability to think critically was not demanded of them while in high school. In college, this ability is crucial (Light, 2001, p. 38). Critical thinking means you have the ability to consider some item, let's say a work of literature, a critical essay, or a philosophical argument, and so forth, assess it, analyze it, and formulate an informed, in-depth understanding of that item. And it means you are able to discuss and defend your findings.

In college, your professors will expect you to voice opinions that show increased originality and independent thought. They will expect your papers to demonstrate increased sophistication supported with research that is more advanced than that which you have previously produced. This means that, for many of you, your current writing skills are not at the level you will be quickly expected to achieve. This is one of the main areas where seeking out help will be most beneficial. Most colleges have a writing center that is staffed to help individuals improve their writing skills. And don't be deceived—as with all areas of learning, bettering one's writing skills is a lifelong endeavor; the room for improvement doesn't ever stop. And so, don't ever feel embarrassed to ask for assistance.

Also, there are some simple traps you'll want to avoid. The first is the notion that you can write one draft of an essay or paper and hand it in as though complete. Nobody who takes pride in their writing believes one draft is sufficient and virtually every professor feels the same. They expect you to show pride in your work. It is amazing to me how many students hand in papers that are riddled with typos; a clear indication of carelessness, lack of pride, laziness, or any combination thereof. First drafts are notorious for containing typos, odd syntax, grammatical errors, and arguments that lack clarity. Start getting used to the idea that you will need to write several drafts of a paper, each time clarifying and refining your thoughts and arguments, each time cleaning up spelling, structure, and punctuation. Get yourself a writing guide. *The Elements of Style* by Strunk and White is great, simple, and straightforward.

The ability to write well is not just important while in school but is also a crucial skill for success in most careers. In a survey taken of college alumni, more than 90 percent ranked the need to write effectively as a skill they considered of great importance in their current work (Light, 2001, p. 54). Ninety percent! This is true of career fields as diverse as journalism, law, medicine, business, education, and the arts, to mention just a few. So practice writing. Write and rewrite and rewrite again.

A second trap, that also is quite often an indication of laziness, is the belief that when writing a paper or essay one can get a good grade just by meeting the minimum expectations. This is a fallacy. A minimum is just that, a *minimum*. Anything less than the minimum will more often than not result in failure of the paper. If you are required to write a minimum of 500 words and you write 400 words, most professors are not going to give you "partial credit." You did not meet the *minimum* requirements. If your minimum is 500 words and you write 500 words, your writing will need to be spectacular to have a chance at getting a "B" or above. If you just meet the minimum requirements and your writing is just adequate, you'll likely score in the "C" to "D" range. A sure way to expect an "A" on your paper is to not only meet the minimum requirements but to *exceed* them. Demonstrate effort and take pride in your work, and you will succeed.

A third trap is the notion that the Internet is the sole source of research you will need. Most often this is also a fallacy. In fact, when conducting research, you will need to find material from multiple reliable sources including scholarly books, articles from peer-reviewed journals, other articles from newspapers, newsmagazines, other popular journals, and so on. You will need to be able to discern reliable and academically sound sources from those that are not. If you are one of those students who believe that all you need for a research paper can be found by Googling your topic, you are about to make one of the biggest mistakes new college students make. The Internet is both a goldmine and an outhouse—go digging and you may find gold but you're just as likely to find crap. Until your knowledge of scholarly work is advanced enough to sift out the crap, stay away from simple

Internet searches. Instead, seek out a librarian who can help you conduct proper research.

Therefore, take advantage of your library. Ask for an orientation tour. Learn how to use everything the library has to offer. There are many librarians who are happy to take the time to teach you how to find the proper materials you will need to write a high-quality paper. I had a student who once told me she hated going to the library. She didn't say why. Maybe one of her high school teachers made her feel stupid because she didn't know how to research something. Perhaps the sheer size of the library and the amount of material contained therein was overwhelming. Whatever the case, if you also feel like you don't like the library—GET OVER IT! University students use the library. "A" students know how to use it well and to their advantage.

You should also be aware that your professors are going to expect greater punctuality when handing in work and most will be less forgiving than your high school teachers when it comes to missing deadlines. For the most part, if you miss a deadline, whether for a paper, a reading, an assignment, or exam, you may not be granted an extension. This, as with most things related to your classes, is most often determined by each professor individually. Some may forgive everything while others will forgive nothing. I, myself, am not very forgiving when it comes to assignments being handed in late. With regard to all your academic deadlines, you will be expected to keep track of them. There will be no one reminding you that you have this paper due tomorrow or that homework assignment next week. Several of your classes may have a midterm exam but each may occur at a different time in the semester. This means that depending on how many classes you are taking, you may have an awful lot on your plate to keep track of. It would be advisable to keep a portable weekly calendar within which you can write down all deadlines as listed in your syllabi and class schedules. You can check this on a daily basis to keep track of upcoming deadlines. Being organized can make the difference between getting an "A" or a "D."

I'd like to briefly address one issue now that has students failing my class every semester. That issue is cheating. This is the area where I am least forgiving; whether cheating on a test or exam or plagiarizing a paper, in my class, any form of cheating results in automatic failure of that class. There

is a much bigger discussion about the purpose of education woven into this issue of cheating, not to mention the moral implications. Suffice it to say that cheating is wrong. But more importantly, cheating robs students of the opportunities to learn and exercise critical skills and to enjoy experiences that are an essential part of learning. We see way too many examples of cheating happening through all walks of life, whether in the corporate boardroom, in the newsroom, or in the classroom. Cheating is about greed; cheating is about laziness. Cheating becomes a habit. Done once, it becomes easier the second time, and then still easier the third time, and so on, until before you know it, you are doing it on a regular basis. Rest assured of this one fact: at some point you will get caught, and when that occurs, the price can sometimes be quite high. As I said before, in my classes, it results in automatic failure of the class. As you pursue your studies, remember why you are here—to learn. Your degree will mean nothing if you don't have the knowledge necessary to back it up. Education is not entertainment. It requires hard work. In a fast-food society, we are brought up to expect immediate gratification for the least amount of effort and expenditure. Education cannot be had on the cheap and quick. Education takes time and requires effort.

As mentioned, cheating robs a student of some crucial skills that need to be developed and exercised; skills that can only be exercised through actual application. These abilities are those same skills that will be needed and used during the course of one's career. The Greek philosopher Aristotle said that excellence is a habit. If this is true, then, as with all habits, excellence is something that is arrived at through repeated application. Excellence can be seen as a muscle that requires regular exercise to be strengthened. As Jane M. Healy asserts, students soon forget three-quarters of what is commonly taught and tested. This means that students must approach learning as the habitual practice of skills and not simply the retention of needed facts to pass a test. Education goes beyond memorization or simply stuffing the brain full of what will be "on the test." It, in fact, requires "careful reading, mathematical reasoning, note-taking skills, understanding abstract concepts such as irony or inertia," all of which are habits "that require extended practice throughout the school years. These skills are the ones we internalize, use, and will increasingly

need in the future" (Healy, 1990, pp. 311–312). Every time students cheat, those students are robbing themselves of an opportunity to exercise needed skills by circumventing the application of those skills. It has been determined that the brain's synaptic structure, it's actual physical development and how its intelligence is expressed, is determined by the stimulus to which it is exposed. The way the mind is used determines its capabilities and its functionality (Healy, 1990, p. 81). This, then, makes physical the notion of excellence as a habit.

The deterioration of the previously mentioned skills (clear and sophisticated writing, comprehensive researching, and critical, original thinking) all contribute to what corporate leaders have cited as "America's loss of its competitive edge" and the "unemployability of American youth" (Fowler, 1996, p. 99). Only you can reverse this trend. Only you can determine whether or not you will fall into the category of the unemployable or whether or not you'll surpass those who would be your competitors. You will need to develop your excellence, and since excellence is a habit, you will need to work at it.

DISCIPLINE: TIME MANAGEMENT, RESISTING TEMPTATIONS AND DISTRACTIONS

Your greater independence will necessarily mean you will need to get better at time management. Each of your professors will be assigning you work and some may assign an awful lot. This will mean that you will have to do work at home, in the library, on the train, in the cafeteria, at the hockey rink, while mowing the lawn . . . you get the idea. Each of them will assign you work without much concern as to how many other classes you are taking, or how much work the other professors have assigned you. Nor will they be concerned with how much you have to practice piano or soccer, or how many hours you spent rehearsing *Othello*, or how many laps you had to swim, or how much time you put into your part-time job. You will have to do it all and get it all done. This means you will need to get organized and learn how to manage your time well.

If you grew up like most American children, then you have spent a lot of time watching television. TV viewing and all "screen time" activities can become a habit, only in this case, a less than constructive one. On average now, most American children spend more hours in front of the television than at any other activity except sleeping. And, as Jane Healy points out, high school students spend approximately six times more time in front of the television than they do doing homework (Healy, 1990, p. 196). If you find yourself spending a lot of time in front of the television, playing video or computer games, or engaging with any of the multitude of video entertainment formats or social media platforms be aware of how quickly a habit can become an addiction. It can be argued that many students are, in fact, addicted to these activities. A symptom of this fact can be seen in how many students struggle to get through an hour-long class without pulling out their cell phones to text message or play a game. And before you dismiss this idea with a smirk, know that addictions to things like television and cell phones have been confirmed just as surely as addictions to alcohol, drugs, sex, and food. And, in many cases, they have proved just as destructive. Success in college will largely depend on your ability to manage your time well and that will mean the ability to limit the time you spend watching TV or playing on the computer.

It was found that students who enjoyed success in their first year did so because they soon realized that they had to pay close attention to how they spent their time. They mentioned time management, and time allocation, and time, in general, as a scarce resource. They found that effective time management required systematic effort but that the effort applied paid off by reducing the amount of anxiety the heavy demands of college caused. It reduced the feeling of being overwhelmed that many students encountered when suddenly confronted with the amount of reading and writing required in college. Effective time management means the difference between new students who prosper and those who struggle (Light, 2001, pp. 24–25).

Make no mistake, some students will struggle and some will prosper. What type of student you are will largely depend on the choices you make. As stated earlier, and most significant, is that effective time management requires *systematic effort*. It isn't something one happens upon; it isn't something that will magically manifest itself. It requires conscious and concerted application.

Your newfound freedoms at college can also translate into excessive and dangerous behaviors. Be cautious of how much time you spend drinking

and partying. Without lecturing, you should be aware of how prevalent excessive binge drinking has become on college campuses and how destructive that behavior is. You've heard all the stories and all the warnings and perhaps have learned to shut the warnings out. But if you are smart, you will recognize that addictions to alcohol, drugs, and sex are rampant and that no one is impervious. The dangers exist even for those students who are not addicted. An anecdotal story can serve as a warning.

In our department a couple of years ago, we had a student, a junior. He was talented, got good grades, and was well liked by his peers and professors alike. By all accounts, he was someone who did not drink to excess and who never drove if he had been drinking. One night that changed, and for some reason he decided to drive after drinking; it was the first time he had ever done so. On the way home, he got in an accident and killed someone. He was found guilty of vehicular manslaughter and was sentenced to many years in prison. One stupid mistake made once and—wham!—his life was radically and irreversibly changed. It can and does happen to anyone.

For young women, you need to be aware of how many date rape and acquaintance rape situations arise when alcohol is involved. Protect yourself: keep yourself in safe, controlled environments and avoid excessive drinking. Rape can and does happen to anyone.

College environments are rife with temptations from simply skipping class to play cards with friends to missing class because of a previous evening's excessive behavior. Be cautious, exercise good judgment, and act with maturity. These are all keys to success.

GETTING INVOLVED

An interesting point about time management and academic success is that grades are not necessarily tied to how much time a student spends on non-class-related activity but, rather, how a student incorporates that activity into his or her overall management scheme. This relationship is explored in *Making the Most of College*, where author Richard J. Light makes a significant observation concerning the relationship between grades and extracurricular activity. He finds that for students who are involved in extracurricular activities for up to as much as twenty hours a week,

there is no inherent adverse effect on their grades. In addition, he found that students who work at a part-time job, or who volunteer, or who partake in other activities (other than college athletics), generally receive grades that are as good as those earned by their peers who do not engage in extracurricular activities. Significantly, then, for those students who believe that they must spend their time focused exclusively on class work if they wish to obtain good grades, you can rest assured that this is not the case. In fact, just as important, it was also found that students who are involved in extracurricular activities actually experience greater overall satisfaction with college life (Light, 2001, pp. 26–27).

I would suggest, then, that all students would be best served if they participated in some form of social activity that is not directly related to class work. Everyone, whether studying or working for a living, needs diversion if they are to maintain a happy, healthy outlook on life. If, for whatever reason, you are disinclined to involve yourself in a campus organization or social activity, find something else you can do that is unrelated to class work. This might involve volunteering at an animal shelter or a home for the elderly, participating in a community clean-up, or perhaps tutoring children. Students who are involved are happier.

There is an exception to the relationship between part-time activity and academic success just noted, and that exception is for college athletes. It has been found that they do experience a small decline in their grades. However, what is not clear is if this is because athletes are inherently less academically inclined, which I seriously doubt to be the case; or if it is because the demands on an athlete's time—with scheduled practices, workouts, and travel—are greater than those placed on most other students; or if the amount of mental preparation demanded of athletes causes them to spend more time focused on their sport rather than their class work; or if, for the most part, because their primary area of interest simply lies outside of the classroom and thus they naturally spend less time focused on their studies unlike, let's say, someone studying business or pre-med whose primary area of focus is inherently in the classroom. What should be noted, however, is that college athletes do tend to be some of the happiest students, and that if one were to include satisfaction and happiness in the "academic success" equation, college athletes would rank as very successful.

Another important type of social activity that helps students achieve academic success is studying with other students. Not only do they establish social bonds and develop potential friendships but, just as important, students who study together offer themselves the opportunity to learn from their fellow students. In fact, students who consistently study on their own are found to show greater risk of struggling academically (Light, 2001, p. 40). The college landscape offers students the chance to exchange ideas with classmates; to explore perceptions, understandings, and points of view different from their own; to ascertain the degree to which they comprehend the subject matter being taught—and there is no better way to do this than to study in pairs or in groups. Studying with others helps to create a positive, affirming experience for students, which in turn raises the degree of satisfaction with college life.

LIVING FOR THE PRESENT; LOOKING TO THE FUTURE

All students must realize that, while in college, they will be required to make a lot of choices, many on a daily basis. With those choices will come consequences—some favorable, some not. I spent several years skydiving. Despite being a much safer sport than many believe, it is still an inherently dangerous sport. Injuries and death do occur. All skydivers know that when they jump out of an airplane there is the risk of serious injury. This means that with every skydive made, each skydiver accepts responsibility for the potential consequences. If skydivers were not prepared for those consequences, they would not jump.

This must be true for all of us. Being a mature adult means being prepared to accept the consequences of our choices and taking responsibility for our actions. This means living for the present but looking to the future. Students must look to the day that they graduate and prepare for it. However, that preparation, if done properly, must necessarily mean that the true focus be on living in the present moment, thereby maximizing the learning experience. Being at college means studying and learning; and studying and learning require hard work, commitment, and dedication. These are the same qualities that will

be demanded of students once they enter the workforce, and if those qualities haven't been developed while at college, it will almost certainly be too late to develop them once a student has graduated. What this means is being responsible for your own education.

Being responsible means that if you skip a class, you must recognize that there will be a cost associated with that decision, whether it is an automatic drop in your grade or simply missing what was taught that day. If you find yourself struggling in a class and wait until the end of the semester to address the issue, you must realize that it may be too late to rectify the problem. If you help another student cheat on a paper or exam and are caught, you must accept the consequences. Students who have scholarships that depend on maintaining a certain GPA must acknowledge that fact at the beginning of the semester, and, if their actions during the semester result in grades that drop them below the minimum GPA requirements, the time to regret your actions has passed. Like the skydiver, your choice of whether to jump or not must be made before you are out of the plane. Once you've made the leap, you must accept what may come.

For those of you who are determined to succeed, make the right choices. Get involved in activities outside of the classroom that are rewarding and that will provide you with a sense of satisfaction. Be proactive in your education; seek out help when it is needed, whether from a professor, a tutor, another student, an advisor, or counselor. Learn to manage your time well. Be cautious of activities such as television viewing that are the vast black holes of time consumption. Most important, accept your role as a mature adult. This means accepting responsibility for your actions and decisions. If you made a mistake such as cheating on a test or missing an exam, no matter how serious it is, address it right away and be honest about it. Don't wait until the end of the semester to discuss it with your professor. All professors want their students to succeed, and most are much more willing to work with students who show the maturity to own up to their errors and accept responsibility for bad decisions.

You and you alone are responsible for your success. Remember Aristotle's words about excellence: make it a habit.

WORKS CITED

Fowler, Charles. *Strong Arts, Strong Schools*. New York, Oxford University Press, 1996.

Healy, Jane M. *Endangered Minds: Why Children Don't Think—and What We Can Do about It*. New York, Touchstone, 1990.

Light, Richard J. *Making the Most of College: Students Speak Their Minds*. Cambridge: Harvard University Press, 2001.

Name _____

ARE YOU PREPARED? *by Desmond Gallant*

Review Questions

1. In the article, the author cites Charles Fowler, who identifies several keys to success in the post-undergraduate years. These include self-discipline, pride, and enthusiasm. Discuss what is it about these three qualities that would make them qualify as keys to success. What about the other qualities he includes in the list—what would qualify them?

2. When discussing how to approach education, the author says that students need to know how to actively engage their imaginations. Discuss why this is true.

3. The author states that "true learning is experiential and participatory." Discuss what is meant by this.

4. The author suggests that being an independent and mature student means that "you don't wait to be lead but you lead; you aren't apathetic but involved; you aren't passive but self-motivated." What do you think he means by this?

5. What are some of the "traps" the author identifies as being those students should avoid when writing an essay or paper?

6. At one point, the author discusses punctuality and deadlines regarding class assignments. What is one of the key suggestions the author offers to help students keep track of deadlines?

7. The author suggests that cheating is caused by greed and laziness. Why does he identify these two causes, and can you give examples that would support the assertion?

8. The author quotes Aristotle as saying that excellence is a habit. Discuss how this is true.

9. The author says that "every time students cheat, those students are robbing themselves of an opportunity to exercise needed skills by circumventing the application of those skills." Discuss how this statement is true.

10. The article says that "effective time management requires *systematic effort.*" What does the author mean by this?

11. What are some of the benefits identified in the article that come with students studying together?

12. In the article, the author addresses the sport of skydiving. Discuss the context and why he raises it as a point of consideration.

Research Topics

1. In the article, reference is made to "seven autonomous intelligences"; research what these are specifically and how each of them might be developed through educational curriculum.

2. The article refers to the book *Making the Most of College* by Richard J. Light. Get a copy and give it a read. It just might help make a difference.

3. Go skydiving and when you are about to jump out of the plane, think about the decision you are making. Are you prepared to face the consequences? Once you've landed on the ground safe and sound (keep your fingers crossed), remember this experience as you make significant decisions in school and in your life.

CHAPTER 2

Defending the Arts and Education

PARC SHOWS AUDIENCES VALUE PERFORMING ARTS *by Leonard Jacobs*

Introduction

This article by Leonard Jacobs, from the theatre trade magazine *Backstage.com*, discusses some of the findings presented in the second of three reports associated with a three-year research project that studied the role of the performing arts in American cultural life. In it, Jacobs reports about American perceptions of the performing arts and the importance they represent to American communities and education.

The Performing Arts Research Coalition (PARC), a three-year audience-research project being conducted by five national service organizations, has released the second of three reports on the culture-going habits of citizens in selected cities across America. The figures further confirm that that people attend performing arts-related events more than sporting events. And they place a high value on the presence of the performing arts in areas in which they live, work, and seek cultural outlets.

"The Value of the Performing Arts in Five Communities 2" examines audiences in Austin, Tex., Boston, Mass., Minneapolis-St. Paul, Minn., Sarasota, Fla., and Washington, D.C. Included is data on "participation rates" in cultural activities as well as an in-depth look at the demographics of the attendees themselves. The survey measures the "perceived value of the performing arts" to individuals and communities, and considers the many barriers to increasing

those numbers and what can be done to overcome them.

Financed by a $2.7 million grant from the Pew Charitable Trusts and begun in the spring of 2002, PARC is a joint effort of the American Symphony Orchestra League, the Association of Performing Arts Presenters, Dance/USA, Opera America, and Theatre Communications Group. The coalition has partnered with the Urban Institute, a Washington, D.C.-based not-for-profit research group, to analyze and interpret the data.

The first interim report, issued in April 2003 and focused on audiences in the state of Alaska, Cincinnati, Ohio, Denver, Colo., Pittsburgh, Penn., and Seattle, Wash., also showed that people attend performing arts-related events more than sporting events, and placed a high value on the performing arts.

Approximately three-quarters of those participating in the newest survey reported attending one live professional performing arts event within the past 12 months. While this ranged from a high of 78% for Boston respondents to a low of 71% for those in Sarasota, the numbers nevertheless represent a significant level of continuity across a broad swath of the nation. Moreover, the figures contrast positively with the results of the April 2003 survey, which found a high of 69% in Denver to a low of 61% in Pittsburgh.

The report classifies as "frequent attenders" those who attend a performing arts event at least 12 times in a given year. While the percentages of those falling into this category are a good deal lower, of course, the fact that 17% of D.C. respondents and 11% of Minneapolis-St. Paul respondents were classified this way suggests that audiences' interest in the arts is as wide as it is deep.

When it comes to the menu of cultural choices—say, a performing arts event versus a sporting event—the survey takes great care not to suggest that it is all an either/or dynamic. While "more people have attended a live performing arts event at least once in the past year" than a professional sporting event, arts attenders also tend to be "active citizens who participate in a wide range of activities and volunteer for organizations in their community."

The selection criteria for the report are fairly rigorous. A locale must not only have "representation in three or more of the five national service organizations," but it must also boast enough local arts organizations that "are financially and managerially strong."

To generate the most viable set of analyzable data, the surveys that are employed also vary in type: administrative (examining number of performances, attendance, revenue streams, and expenditures); audience-related (focusing on demographics); subscriber-related (like audience surveys, expanded in scope); and community/ household-related (conducted by telephone to identify those who don't attend the performing arts regularly and what might motivate them to do so).

DRILLING DOWN

Perhaps the most significant similarity between the most recent report and the one issued last year concerns some of the longest-held assumptions about the ages of contemporary audiences—that they tend to be older. The data shows very much the opposite—indeed, a "lack of a strong relationship between age and level of attendance." Economics are a different matter: Perhaps unsurprisingly, nonattenders "show a trend toward lower incomes" and "frequent attenders show a trend toward higher incomes."

Logically, this information makes a good deal of sense: the more disposable income, the more likely one may direct it toward cultural activities. The survey adds that education plays a role in all this, observing "a strong relationship between education level and category of attendance." As the education of the audience member increases, "so also does the percentage who are attenders or frequent attenders."

Several study elements offer psychological profiles of audiences as well. More than 80% of respondents said they have "positive opinions about the level of enjoyment derived from live performing arts" and the statistics suggest, moreover, that such a statement is generally unrelated to the level of household income. The one exception was the participants from Sarasota, where "higher household incomes are associated with greater levels of arts enjoyment."

And in a finding that will buttress the growing body of research that supports the economic benefits of the arts in a community, the report makes an attempt to quantify how audiences feel about the "value" of culture in their environment. For example, "at least" 90% of respondents in each of the five communities said they either "strongly agree" or "agree" that the performing arts "contribute to the education and development of children." A slightly smaller but no less substantial figure—more than

80%—believe the performing arts "improve the quality of life in their community."

Finally, there is the key question of how to improve upon these encouraging statistics—how arts groups can scale the "barriers to attendance," which is the core of contemporary arts marketing efforts. The report cites 11 such "barriers," from the cost of tickets to simply feeling "uncomfortable or out of place at performing arts events."

Here the apparent homogeneity of the five studied communities begins to take a different shape. In Austin, 32% of respondents said they preferred "to spend leisure time in other ways" and 3% indicated they did not attend more arts events because they "have not enjoyed past performances." In Boston and Sarasota, a stunning 41% and 42%, respectively, simply said it was "hard to make time to go out."

Name: _____

PARC SHOWS AUDIENCES VALUE
PERFORMING ARTS *by Leonard Jacobs*

Review Questions

1. This article states that more people have attended a live performing arts event at least once in the past year than a professional sporting event. Why do you think this is?

2. The article states that arts attendees tend to be active citizens who participate in a wide range of activities and volunteer for organizations in their community. Why do you think arts attendees are more active citizens and have a higher degree of volunteerism?

3. The article reports that the study found that the frequency with which individuals attend arts events correlates to their level of education. Why do you suppose this is?

4. The article relates the report's finding that there are "barriers to attendance" and lists two of the eleven barriers. The first of the two is the cost of tickets. Who might this most affect in terms of attendance? The second is feeling "uncomfortable or out of place at performing arts events." Who might this most affect?

5. The article cites that at least 90 percent of respondents either "strongly agree" or "agree" that the performing arts "contribute to the education and development of children." In what ways do you think the performing arts contribute to the education and development of children?

6. The article also states that more than 80 percent believe the performing arts "improve the quality of life in their community." In what ways do you think the performing arts improve the quality of life in your community?

Research Topics

1. This article is based on research involving audiences in five different cities: Austin, Texas; Boston, Massachusetts; Minneapolis-St. Paul, Minnesota; Sarasota, Florida; and Washington, D.C. Identify and describe the artistic mission of a performing arts organization from each of these cities.

2. The Performing Arts Research Coalition is a research project conducted by five national service organizations: the American Symphony Orchestra League, the Association of Performing Arts Presenters, Dance/USA, Opera America, and the Theatre Communications Group. Research and describe the artistic mission of each of these organizations.

DEEP IN THE ARTS OF TEXAS *by Christopher Reardon*

Introduction

In a time when the arts are being increasingly cut from school curriculums, this article by Christopher Reardon reports on how select public schools in Dallas have used the arts to boost student achievement. It describes in detail how the Dallas school district, through a program called ArtsPartners, has integrated the work of artists and arts organizations into the curriculum and revitalized the students' educational experience. It demonstrates what more and more studies are showing: The arts have a profound impact on students and their education, and should have an integral role in every student's academic experience.

Dallas—Ever since Texas adopted a statewide curriculum in 1998, fourth graders here at James S. Hogg Elementary School have spent several weeks each fall studying 19th-century pioneer life in the American Southwest. Their understanding of this dynamic era—when the region's Comanche hunters and Mexican traders crossed paths with English- and German-speaking settlers—initially came from classroom discussions and library books. But now the school is teaming up with local artists and cultural institutions to make this history come alive even more.

In Dallas, thousands of elementary school teachers are integrating field trips and artist residencies into their lesson plans for such core subjects as reading, math, science and social studies. Since 1998 all but a few of the city's 157 public elementary schools have been working with museums, theaters and other arts groups for the express purpose of boosting students' academic achievement. In that time the nation's 12th-largest school district has built a stronger teaching force, engaged students through new ways of learning and brought marked improvement in literacy, particularly writing. As a result, Dallas now serves as a model of curriculum reform for communities from Baltimore and Charlotte, N.C., to St. Louis and Jackson, Miss.

These gains are credited to a hard-won alliance between city government, the school district and the city's arts and cultural institutions. Called ArtsPartners, it has trained 4,500 elementary school teachers and revamped educational programs run by 62 arts groups, from mariachi players to the Dallas Museum of Art.

"It was risky," says Giselle Antoni, executive director of Big Thought, a nonprofit organization that coordinates the ArtsPartners program. "As artists and educators, we had to change the way we saw ourselves and our role in the community."

This new outlook was evident last fall when Hogg's fourth graders traveled across town to the Dallas Arboretum, where typical dwellings from the pioneer days stand beyond a sea of chrysanthemums. The students stepped inside a tepee, climbed aboard a covered wagon, poked around a couple of rustic farmsteads and marveled at a house made of sod.

A few days later, Sara Weeks, an actress who, through the partnership, works as an artist-in-residence at Hogg, came to the class in the playful guise of an inquisitive reporter, complete with a fedora and a notebook. Weeks, who knew most of the class from previous visits to the school, interviewed students about their experiences at the arboretum, teasing out detailed observations, inferences and conclusions about life on the southern plains.

Following their encounter with Weeks, the students wrote about Texas pioneer life in their "history reporter journals," a set of notebooks developed by ArtsPartners to facilitate close observation, critical thinking and written reflection.

The unit served two goals: to educate students about Texas history, in keeping with the statewide curriculum for social studies; and to hone students' skills in narrative writing, in preparation for a state assessment of writing proficiency among fourth graders. The culminating project was writing an essay about the life of pioneers in

From *Christopher Reardon, the Ford Foundation Report*, Winter 2005. Reprinted with permission of the Ford Foundation.

Texas and how they established their homes. For many students, it was Weeks' visit that really got their minds and pencils moving.

"I want them to see that learning can be fun," Weeks said afterward. "But there's more to it than that. I've been to the arboretum, had breakfast with the teachers and gone over the curriculum, so I know what these kids are studying day by day. As much as I love art for art's sake, that's not what I'm doing here. I'm using movement and performance to help them remember details and make connections that they can use later when they sit down to write."

ArtsPartners began taking shape in 1995, when Dallas Mayor Ron Kirk asked a former music and art teacher, Dolores Barzune, to chair the panel that oversees the city's support for arts and cultural institutions. One rationale for underwriting such groups was the strength of their education programs, but Barzune wondered how well they were really serving local schoolchildren.

The city's Office of Cultural Affairs had no system in place for holding these programs accountable. Yet an informal inquiry by Margie J. Reese, its newly appointed director, found that public schools in affluent neighborhoods made repeated visits to museums and theaters, while most others had no contact with them at all. She and Barzune could have let the matter drop; after all, publicizing the imbalance was likely to fuel cynicism or create expectations of improvement that would be hard to fulfill. Instead they took a political risk and vowed to expand access so that all public schools could benefit from the city's cultural institutions.

"We felt it wasn't enough to give city funds to arts groups without impacting children's education," says Barzune. "And not just some children. We wanted to open it up to everyone."

She and Reese knew the city could not fix things on its own. So they set out to win over two crucial allies: the cultural sector and the school district. Essentially, they argued that the arts are central to a good education and that, as a matter of equity, all students should experience them in meaningful ways.

They found a receptive ear in Giselle Antoni, who coordinated many arts education programs through Young Audiences of North Texas, the organization now known as Big Thought. A former actress who had taught theater in prisons and schools, Antoni was not only troubled by the findings of Reese and Barzune, she also felt an obligation to remedy them. She and Reese set up a meeting with Jacqueline Landry, who was then associate superintendent for curriculum and instruction at the school district, which serves 161,000 students and has a $1.4 billion operating budget.

"They won me over when they started talking about equity," says Landry, who now oversees professional development and staff training for the district. "That was my spark. I wanted to make sure every child gained access to these activities."

For more than a year, this trio—Reese, Antoni and Landry—met with colleagues in city government, at cultural institutions and in the school system. Through these conversations they identified three ways to make field trips and artist residencies more worthwhile: (1) link them closely to the core curriculum, with academic achievement as the ultimate goal; (2) make them available to every public school in Dallas; and (3) let teachers, not the school district officials or arts administrators, decide which activities best meet their students' needs.

To advance these goals, they brokered a formal partnership among their agencies—the city's Office of Cultural Affairs, Young Audiences of North Texas, and the Dallas school district—and named it ArtsPartners. The partnership serves as a clearinghouse where teachers can pair up with artists and arts professionals from the city's cultural institutions. Its program also develops instructional materials and trains classroom teachers, visiting artists and museum docents. In fact, each elementary school teacher in the district receives between 10 and 50 hours of training per year, an investment that is transforming teaching practice on a broad scale. Unlike many celebrated school reforms involving top teachers or boutique schools, this one is making an impact throughout the district.

But before ArtsPartners could get off the ground, many cultural institutions had to rethink their educational programs.

"Our goal is to help kids read better, write better, learn better," Antoni explains. "So at some point we had to put our stake in the sand and say this program isn't designed to build audiences, although it may. This program is designed to help teachers teach more effectively."

ArtsPartners replaces the field trips of old—critics call them "drive-by art"—with a more purposeful model. First, teachers at each grade level in a given school meet to clarify their instructional goals. After speaking with the ArtsPartners staff

and consulting an online database, they select an activity that ties into their lesson plans and advances the state-mandated curriculum. Next, they prepare students with help from teaching guides developed by ArtsPartners and educators at cultural institutions. After each field trip or performance, teachers build on their students' experiences through classroom discussions. Often this involves a second cultural encounter, as when Sara Weeks, the actress, helped fourth graders at Hogg reflect on their trip to the Dallas Arboretum. Finally, teachers give writing assignments to see what students have learned.

"Before ArtsPartners, teachers weren't always aware of what was out there," says Cheryl Malone, the principal at Thomas L. Marsalis Elementary School, which serves a predominantly African-American community on the city's south side. "And if they were aware, they didn't know how to use it effectively."

Now, with training and teaching materials provided by ArtsPartners, they are more adept at integrating cultural activities into the curriculum.

"I've gone on a few field trips with the kids and I was blown away," says Malone. "When we visited the Dallas Museum of Art, it was obvious that a lot of teaching had gone on ahead of time. The kids knew what they were looking for, and they spoke at a very high level about finding meaning in works of art. Then they came back to the school and did some additional research on the Internet and wrote about it. It was a beautiful thing to watch."

The cultural sector has also embraced the idea. At first, some artists and administrators worried that the partnership would cut into their revenue—taking grant money that once flowed directly to arts groups and cultural institutions. But ArtsPartners has made a point of telling donors that it only accepts new or increased funds.

In 1998 ArtsPartners launched a pilot program in 15 schools, making sure to select at least one in each city council district and school board district to keep it politically viable. They added 13 schools the following year, then 49 more the year after. By its fifth year, the partnership was serving 101,000 students and 4,500 teachers in more than 150 schools. The marked increase in the number of visitors from Dallas public schools has been a boon to the cultural sector.

The cost of running ArtsPartners averages roughly $2.7 million a year. The school district picks up about a third of the tab, or $880,000, which pays for buses, artist fees and admission charges. Another $220,000 comes from the city's Office of Cultural Affairs, which also gives $4.1 million directly to arts groups and cultural institutions. Federal initiatives provide about $625,000, much of it for ArtsPartners' work in after-school programs. The other $1 million comes from the private sector, including businesses, foundations and individual donors.

As it grew, ArtsPartners had to contend with instability at the school district, where six different people held the top post between 1996 and 2001. But the program won favor with Mike Moses, who became superintendent in January 2001. Moses had previously served as the state's commissioner of education, and led the movement to promote standards and accountability in public schools. Like many others, he came to value ArtsPartners because it brought measurable benefits.

"In Texas, there's almost as much pressure for teachers to boost test scores as there is for coaches to win football games," says Larry Groppel, who was named interim superintendent when Moses resigned to take a university job last summer. "Here in Dallas there's probably more. If somebody wants to criticize ArtsPartners as fluff, they should look at the test scores."

Indeed, initial analyses of standardized tests administered throughout the district show that students make bigger strides in literacy, particularly writing, when their teachers book performances, artist residencies and other cultural activities through ArtsPartners. The effect is greatest in schools that receive help integrating these activities into their lesson plans. The scores of students who received the greatest exposure to ArtsPartners' programs rose 10 points in a statewide reading test between 3rd and 4th grade compared to a three-point rise for a control group. What is more, the program seems to benefit students of every ethnic, socioeconomic or academic grouping.

Dennie Palmer Wolf, a scholar at Brown University's Annenberg Institute for School Reform, heads a continuing effort to measure the effects of the ArtsPartners program in greater detail. In 2001 her team of researchers began monitoring four first-grade classes and four fourth-grade classes—including some at Hogg and Marsalis—that work closely with ArtsPartners. Looking beyond test scores, they have been observing classes, interviewing students and assessing writing samples to gauge the program's influence on how

students behave, think, talk and write. The researchers have also followed several comparable classes that set up field trips and artist residencies through ArtsPartners but did not receive additional training or help in tying these activities into their lesson plans.

The researchers are now following the younger set of students into fourth, fifth and sixth grades. Data from the first three years of the study show that students performed better on their writing assignments—which were scored according to their use of ideas, organization, voice, word choice and syntax—when they received enriched programming through ArtsPartners. For example, in one study, fourth graders scored an average of 2.39 for use of ideas in conventional writing assignments. But when they wrote following an ArtsPartners activity, the average score climbed to 3.06.

"This program makes a difference at exactly the moment in exactly those areas where kids with fewer advantages begin to fall off the map," says Wolf, noting that many disadvantaged students slip far behind between first and fourth grade.

"The students at Hogg, for example, who are mostly English-language learners from poor neighborhoods, are turning out the kind of writing you usually get from wealthier, more advantaged students. By fourth grade, a number of them are writing as well as sixth graders elsewhere in the district."

Still, ArtsPartners faces many challenges. The organization's work with teachers throughout the school district has clearly had an effect on teaching quality. Still, most schools only have the money and time for two ArtsPartners activities each year. Funding is always uncertain, and the cost of expanding the enriched program beyond the four treatment schools, or into higher grades, could be prohibitive. Personnel changes also pose a threat, especially with the district again looking for a new superintendent. But advocates for ArtsPartners have proven adept at winning over newcomers.

"The trustees will make this part of the interview process" for superintendent, says Ken Zornes, a member of the school board since 1999. "I suspect that if a candidate said it's no big deal, that interview wouldn't last much longer."

ArtsPartners has so many champions within the school system, from teachers and principals on up, that it would be hard for anyone to eliminate it. But Antoni is taking no chances. To shore up support for the program, and its expansion, her staff has begun working directly with parents to build a broader constituency. Such a groundswell, coupled with the testimony of educators like Debra Polk, would be hard to resist.

"We used to take trips to free, affordable places," says Polk who teaches language arts to fourth graders at Marsalis. "Now we go to places that connect with what we're doing in the classroom and make a difference in student achievement."

That enthusiasm was palpable one Friday last fall, when Sara Weeks paid a visit to Marsalis. "When the bell rang at the end of the period, my students did not want to leave," Polk recalls. "And at the end of the last class of the day, my students did not want to go home for the weekend."

Name: _____

DEEP IN THE ARTS OF TEXAS *by Christopher Reardon*

Review Questions

1. What skills did ArtsPartners hope to develop by having students write in their "history reporter journals"?

2. The article refers to an informal report by Margie J. Reese in which she found "that public schools in affluent neighborhoods made repeated visits to museums and theatres, while most others had no contact with them at all." Why do you think there is such a difference between the two groups? Is it fair? If not, what do you think can be done to balance out the disparity?

3. What three ways were identified to make the field trips and artist residencies more worth-while? Why do you think they decided these three were so important?

4. The article says that data from the first three years of the study showed that students whose curriculum was enriched through the ArtsPartners program performed better on their writing assignments. In which ways specifically was their writing improved?

5. The article states that as the ArtsPartners staff has been trying to shore up support for the program, including its expansion, they are looking to add a new component to the constituency of supporters. What is that new component? Do you think they should have any trouble gaining the support of that new constituency? What objections, if any, might be raised? What benefits does the program offer that might win them over?

CHEATING OUR CHILDREN: WHY EVERY CHILD NEEDS THE ARTS *by Charles Fowler*

Introduction

In his groundbreaking book *Strong Arts, Strong Schools,* author Charles Fowler makes a strong case for the arts as an integral part of a well-rounded education. His arguments are carefully considered, clearly defended with rational, logical, and insightful thought, and supported with significant studies that render its assertions as authoritative.

In "Cheating Our Children: Why Every Child Needs the Arts," he discusses how studying the arts benefits all students and why the arts then should be made an intrinsic part of the curriculum. He argues that the very processes involved in the creation of various forms of artistic expression "helps youngsters discover their own resources, develop their own attributes, and realize their own personal potential."

He explores the thinking processes employed by the arts and the many ways the arts impact the students developing mind, spirit, and sense of self. He illuminates the ways studying the arts better prepares students for their future as productive, socially well-adapted, working adults. More important, he articulates what the arts really are: advanced systems of meaning and acts of intelligence employing structures of symbols that enable us to represent our ideas, concepts, and feelings in a variety of forms. They are modes of expression that are intrinsically human and define who we are as a species of thought and spirit.

Like other subjects in the curriculum of American schools, the arts provide an opportunity for children to realize certain talents and potentials. Particularly in their creative modes, the arts ask students to reach inside themselves to explore their own fascinations and perceptions and to give them suitable and precise representation. In the process of translating their inner discernments and revelations into a symbolic form, children discover and develop their capabilities and uncover some of their human possibilities. Because they are so personal in what they require of each would-be artist, the arts can disclose important insights and impart crucial—and practical— habits of thought that are generally not taught as well through other subjects.

It is precisely because the creative act flows from the inside out rather than the outside in that it helps youngsters discover their own resources, develop their own attributes, and realize their own personal potential. Education generally does not do this. That is, usually students are told, "Here is the way the world is," rather than asked, "What do you think the world is or might be?" Through the process of refining their own personal visions, students discover and develop their own intellectual resources. Because the arts ask students to determine their own abilities, they are self-motivating. They propel and stimulate, fascinate and captivate because they engage students personally with their true inner selves, not some concept of self imposed from outside. All human beings want to know what they can do. By having to draw on their own ideas, students discover and explore their own cognitive capacities.

I believe that engagements with the arts can contribute significantly and uniquely to personal development in several essential ways, changing people's inlook and outlook thought processes and abilities and generally making them more capable of coping with the world around them. Therefore, every child needs the arts, for some or all of the following reasons.

TO HELP THEM DEFINE
WHO THEY ARE

As individuals, we all are originals, but how and when do we realize this? Much of education teaches us to mold our lives to the demands of external conformity. Our individual uniqueness emerges gradually as we probe our personal resources. We have to find it internally by listening to our own inner voice. We have to discover and learn to savor our original way of being human. Charles Taylor, a professor of philosophy and political science at McGill University, notes:

> There is a certain way of being human that is *my* way. I am called upon to live my life in this way, and not in imitation of anyone else's life. But this notion gives a new importance to being true to myself. If I am not, I miss the point of my life; I miss what being human is for *me*.

Taylor believes that we define ourselves "through our acquisition of rich human languages of expression," including the "languages" of the arts. These modes of expression must be acquired, largely through exchanges with others:

> We define our identity always in dialogue with, sometimes in struggle against, the things our significant others want to see in us. Even after we outgrow some of these others—our parents, for instance—and they disappear from our lives, the conversation with them continues within us as long as we live.

This interchange between people, facilitated by our ability to express and communicate, lies at the center of making and sustaining our identity, of recognizing our authenticity. Each person is unique and deserving of respect because of this shared universal human potential.

The arts invite us to express our own visions and values and to explore the world from our own viewpoint and perception. They help us cultivate particularity and individuality. Through creative involvements in the arts, we make choices, and in the process we determine our own self. We come to respect diversity because we learn to respect our own differences and singularity.

Self-esteem is established by just such inner searches. By recognizing who we are and by giving voice to our personal inner life, arts education induces self-respect. It legitimizes self-identity. Doubts about ourselves operate conversely, causing degrees of self-denigration, whereas self-respect grows through positive reinforcement. We tap our inner resources and, because of them, are able to command affirmation and recognition. Our dignity and self-respect as individuals reside in achievement, and the arts provide legitimate ways to achieve and to win recognition.

TO SEE THEMSELVES AS PART
OF A LARGER CULTURE

Our culture—defined as the way in which we choose to live and what we choose to value—is a human creation. At the same time that we learn our idiosyncratic nature, experiences with the arts teach us to appreciate the commonalities that undergird our collective life: our right to express and communicate, our belief in our individuality and our freedom to assert it, our respect for our differences, and our right to dissent. The arts establish our relationship with what is universal in human existence—love, human dignity, and caring and also hate, greed, suffering, and so on.

Artistic expressions introduce students to a wider world. They help students comprehend the human condition, by showing perspectives that can stretch and challenge their viewpoint. They help students learn to exist in a broadened horizon, recognizing and respecting an expanded universe consisting of options outside their own traditions and their individual points of view.

A culture's artifacts necessarily reveal the nature of that culture, how and what it expresses and its general characteristics. Through artistic representations, we share our humanity. What would life be without such shared expressions? How would such understanding be conveyed? If we are to survive, we will need all the symbolic forms at our command because they permit us not only to preserve and pass along our accumulated wisdom but also to give voice to the invention of new visions.

The arts help students see beyond the limits of their own cultural story. By introducing them to the multiple facets of their own and other civilizations, past and present, their horizons are extended. They learn to respect values other than their own. By learning to respect the distinctive arts of others, students learn to respect the people who created them as equals.

TO CULTIVATE AND BROADEN
THEIR PERCEPTION

One of the reasons we read novels is that the characters in them are drawn sharply, clearly, and vividly.

We can understand them in a way that is less possible in real life, and these revelations help us see all people and ourselves better. We can experience pain and suffering at arm's length. The arts awaken us to our feelings and to nuances of sensation. They make us more alert to the world around us.

Increasingly, the arts are being viewed as *systems of meaning*, as living histories of eras and peoples and as records and revelations of the human spirit. They are being viewed as symbol systems as important as mathematics and science. Harvard professor emeritus Nelson Goodman points out that science doesn't have the edge on truth, only one perspective out of an infinite number of possibilities. Science is always self-correcting. Its truths evolve and change. But that doesn't negate its importance. In this sense, science is like art, always presenting new views and new responses to the world.

The arts are *acts of intelligence* no less than other subjects are. They are forms of thought as potent in what they convey as mathematical and scientific symbols are. The Egyptian pyramids can be "described" in mathematical measurements, and history can hypothesize about how, why, and when they were built, but a photograph or painting of them can show us other equally important aspects of their reality. The arts are symbol systems that enable us to represent our ideas, concepts, and feelings in a variety of forms that can be "read" by other people. The arts were invented to enable us to react to the world, to analyze it, and to record our impressions so that they can be shared.

Is there a better way to gain an understanding of ancient Greek civilization than through its magnificent temples, statues, pottery, and poetry? The Gothic cathedrals tell us about the Middle Ages just as clearly as the skyscraper reveals the modern age. The arts may well be the most telling imprints of any civilization. In this sense, they are living histories of eras and peoples and records and revelations of the human spirit. One might well ask how history could possibly be taught without including them.

Today's schools are concerned, as they rightly should be, with teaching literacy. But literacy should not—must not—be limited to the written word. It should also encompass the symbol systems of the arts. If our concept of literacy is defined too narrowly as referring to just the symbol systems of language, mathematics, and science, children will not be equipped with the breadth of symbolic tools they need to represent, express,

and communicate the full spectrum of human life.

What constitutes a good and adequate education? Today, the goal has become very practical: employability. But is that enough? Few would take issue with the notion that children should know how to read, write, and compute. But what about developing human values, such as the ability to get along with other people, to respect human life, to maintain integrity, to be fair and just? The arts affect the mind and spirit. They bring enlightenment to the area of human values and the meaning and possibilities of our existence.

The arts can expand consciousness. They can open eyes, ears, feelings, minds. Encounters with the arts invite students to explore new meanings of themselves and the human condition. They awaken curiosity, present new perspectives, stimulate personal involvement, and convey different ways of looking at themselves and the world. Through their encounters with a work of art, students learn that the more of themselves they put into it, the more they will derive from it. The more they probe and explore, the more they will discover and understand. The payoff is built right in. Students feel the excitement in bringing a work alive, of learning to use their energies for the reward of revelation, and this is an attribute that has important applications in any work situation.

It is one of the important provinces of the arts that they challenge the status quo. The continuing political turmoil over the National Endowment for the Arts and the controversy surrounding grants to photographer Andres Serrano and other artists because of works that some critics have labeled blasphemous and indecent reside in this miscalculation (misconception) of what the arts are and whether public funds should be used to support them. By their nature, the arts seek to show us new dimensions. They critique life. They make judgments of the world, some of which we may not find compatible with our own views.

Irwin Edman tells us that through art, we learn to see the world in new and hitherto undreamed of patterns: "A picture by Cézanne of a snow-laden tree among fallen snows may give us for the first time an inexpungeable sense of the reality of a tree." The arts continually attempt to rescue us from our delusions, counter our smug complacency, challenge the commonplace, and give us a new and sometimes contentious account of life. Do people benefit from being confronted by such options? These new ways to view the world stretch

and sometimes squash our accustomed way of seeing and believing. They challenge us to see and to think differently. We can either accommodate these new views or reject them. In a democracy, alternatives are an essential part of our freedom to express and even our right to offend.

TO EXPAND THEIR ABILITY TO EXPRESS AND COMMUNICATE

Every symbol system functions as both a system of meaning and a means of understanding. The arts are areas of inquiry, ways of knowing that all humans need. As human beings, we are unique among all forms of life because we capture our experience through symbol systems. We cannot adequately convey the range of human experience through written and spoken words alone. How could we express our religious beliefs and our deepest human joys and sorrows if it were not for the arts?

All art forms function as tools of expression and communication, the ways in which we humans seek to know. They permit us to cast our own perceptions and to capture the perceptions of others. To become an expressive, communicative being is the essence of our personal human spirit. When that possibility is denied to young people, they acquire little pride and less enthusiasm. Perhaps that is why drugs, crime, hostility, indifference, and insensitivity tend to run rampant in schools that deprive students of instruction in the arts.

One of the major requirements of education is to give children the breadth of symbolic tools they need to represent, express, and communicate every aspect of human life. If our concept of literacy is defined too narrowly as referring to just the symbol systems of language, mathematics, and science, children will be shortchanged. Howard Gardner pointed out that schools restrict the development of the human intellect by concentrating on nurturing only the linguistic and mathematical/logical parts of the brain. Children must have access to these forms because as Elliot Eisner observed, "The apotheoses of human achievement have been coached in such forms."

The arts, like the sciences, are windows on the world. Creative writing, music, theater, visual arts, media, (film, photography, and television), architecture, and dance reveal aspects about ourselves, the world around us, and the relationship between the two. The arts constitute "an ensemble of stories we tell ourselves about ourselves."

In 1937, German planes flying for Franco in the Spanish Civil War bombed a defenseless village as a laboratory experiment, killing many of the inhabitants. In *Guérnica*, Pablo Picasso painted his outrage in the form of a vicious bull surveying a scene of human beings screaming, suffering, and dying. These powerful images etch in our minds the horror of a senseless act of war.

Similar themes have been represented in other art forms. Benjamin Britten's *War Requiem* gives poignant musical and poetic expression to the unpredictable misfortunes of war's carnage. Britten juxtaposes the verses of Wilfred Owens, a poet killed during World War I, with the ancient scriptures of the Mass for the Dead. In Euripides' play *The Trojan Women*, the ancient art of theater expresses the grievous sacrifices that war forces humans to endure. The film *Platoon*, written and directed by Oliver Stone is a more recent exposition of the meaning of war, a theme that has been treated again and again with telling effect in literature throughout the ages. The theme of humans inflicting suffering on humans has also been expressed through dance. One example is *Dreams*, a modern dance choreographed by Anna Sokolow, in which the dreams become nightmares of Nazi concentration camps.

This theme and many others are investigated, expressed, and communicated through the arts. The arts erase nothingness. Even if they deal with the subject of nothingness they evoke somethingness. They provide expanded awareness. They intensify and extend consciousness. They bring us face to face with our lives, what we have avoided, and what we may not have personally experienced or felt—not always comfortable revelations, but certainly instructive. They help us transcend our blandness. In this way, the arts can function as an antidote for wasted, meaningless lives. It always amazes me how little many people ask of life. They seem content with everyday routine and a lack of self-exploration and fulfillment. The arts break through such dullness.

TO ESCAPE THE MUNDANE

Paradoxically, at the same time that the arts can clarify reality, drawing our attention to what we might have overlooked or simply missed—say, the horrors and hurts of war—they can also take us into new and unexpected worlds, like the joy of Mr. Bojangles dancing. The music that young people choose to listen to helps them transcend

the sometimes harsh and unaccommodating world they may live in. Through the arts, they enter another state, one that is distracting and non-threatening and one that they can control.

The arts sharpen reality; they can also provide a temporary mental release from actuality. Movies and novels, in particular, enable us to lose ourselves in another environment and time, inhabited by characters who are fascinatingly different from the people we know. All of us benefit from having a respite from the trials and tribulations of our everyday lives. The experience of entering a different universe gives us perspective on our own existence. It helps us break loose from our own limited sphere to enter into and realize the potentials and predicaments of the unknown and unfamiliar.

Such respites are an important way that we renew and refresh ourselves, a necessary function of personal rejuvenation. The arts stretch us beyond the mundane and commonplace by activating our imaginations to create a wholly different existence. A love song, for example, can tell us that the joyous state of love is larger than life, certainly bigger than life without it. These imaginative states are compelling because they show the possibilities of life in positive ways, a psychologically necessary and reassuring process. The paradox is that in losing ourselves, we regain self, a being refreshed and renewed by the simple act of diversion.

TO DEVELOP THEIR IMAGINATION

Of all the capacities of the human mind, imagination may be the most unusual and momentous. By exercising imagination, humans have been able to transform and reinvent the world in infinite arrangements. Our evolving adaptations, adjustments, recyclings, and inventions enable us to cope and to survive. By using our capacity to imagine, we reinvent our lives every day, and we invent our future as well. Imagination enables us to burst the confines of the ordinary. It allows us to rise up to meet new challenges and to improve the human condition. One of the valuable outcomes of education, then, is an expansion of imagination.

It is the capacity for invention that carries a civilization to new plateaus. Our searches for new solutions depend on our ability to look at our situation anew, to fabricate alternatives, and to reconceive our lives. We literally formulate our possibilities. In the play of children, invention is abundant, but it is a quality seldom cultivated in schooling. By the fourth grade, students generally have lost much of their will to invent, as though it is a childish propensity best to be relinquished. Schools and teachers generally discourage the inclination to think out and see beyond. We tend to teach unquestioning acceptance and shut out critical and creative reevaluation, rethinking, and reformulation, and in the process, modern civilization loses some of its options and flexibility.

Every human being should not only be aware of, but also learn to apply and to venerate, his or her inventive possibilities. The quality of imagination is a treasure that each of us should savor and respect. Young people are, by nature, explorers, eager to encounter the untried and investigate their quiescent (latent) possibilities. It is the human mind operating at its best. When it is respected and explored, the originality of each human being becomes a way to save the schools from the irrelevance and boredom that prevail in so many classrooms. Personal invention is self-absorptive and wholly involving, human engagement in a necessarily meaningful context.

The arts and human imagination are irrevocably interlocked. Artists are always trying to create something new. As a painter, "you're always trying to make something that has never been seen," declares Brice Marden, "You're trying to make something you'd like to see. You do not see it anywhere else, so you make it. When it's not a surprise for you to see, you do not make it." Only the capacity to wonder and to daydream—not usually qualities that are respected in schooling—permits us to create such surprises.

The problems posed by artistic creation do not have easy answers, and in this regard they are analogous to life. Indeed, they may have more than one correct answer and certainly many ineffectual ones. Understanding such ambiguities can have many applications at home and at work. Two plus two equals four is not relevant to the kinds of difficult thinking and decision making we are required to make so often in the adult world. Through encounters with the arts, students experience the exhilaration of traveling beyond the simplistic true false and right wrong litanies that prevail in most American classrooms.

Joyous as it may be, the act of creation demands enormous self-discipline and teaches students to learn how to handle frustration and failure in pursuit of their idea. It requires setting goals, determining a

technique, figuring out how to apply it, and continually making evaluations and revisions, in other words, thinking and solving problems.

TO LEARN TO EVALUATE AND MAKE JUDGEMENTS

A student who is attempting to translate, say, the battle of Gettysburg into a pictorial representation faces an infinite number of options—and decisions. What is the message? What moment of the battle should be depicted in order to convey that message? What technique, size, scale, color, and form are appropriate? The student makes these decisions because there is no way to proceed without doing so. Early on, these judgments may be made by intuition, by guesswork, or by personal preference rather than by application of an established set of criteria. But some kind of criteria must be used to make such decisions and to justify them, even if it is limited to "I like it" or "I don't like it." The justification for our preferences and tastes has to be educated.

Some of these judgments or preferences will prove easier to make than others. The students may not have a choice of different sizes of paper and so must accept what is available and make the best of it. On the matter of what to depict, however, there may be difficult choices and decisions. The students must imagine various possibilities and make a choice based on what will work best to accomplish their goals and what they can do given their personal limitations and competencies and their consequences. In later stages of development, the students will have acquired a more explicit set of criteria by which to make such determinations. Some decisions may become more automatic while others continue to be anguished. Through the creative process, students are forced to make judgments, and they necessarily develop a set of criteria by which to make them. They learn how to exercise judgment and how to justify their decisions.

In the process of making such judgments, a person's value system is developed. A constant critiquing of results (consequences) may suggest and necessitate adjustments and midcourse corrections, changes of purpose or message, or possibly even abandonment. Students learn to appraise,

that is, to judge the worth of operating one way or another. Leaning on the thoughts of John Dewey, Mary J. Reichling, a professor at the University of Southwestern Louisiana, ties such judgments directly to imagination:

> How one selects among various means and consequences is by using imagination. Perhaps this defines one aspect of the teacher's role: that is, to assist students in imagining all eventualities possible to insure that the desired consequences will actually result and be prized when they do occur. . . . While teachers cannot impose values, they can help students to see the results of their actions or dispositions if they are able to envisage the consequences.

In making aesthetic judgments, students learn that their creative attempts have to be exercised within boundaries that they establish. In the process of creation, being too open ended can be debilitating. Most creation is accomplished within limitations and for good reason. Eliminating some of the options simplifies the complex decision-making process. Painters start with a certain size canvas and palette of colors. Composers start with an established form and have in mind a particular performance medium. Writers start with a poem, a short story, or a novel in mind. These decisions still leave many judgments to be made but they don't leave the artist floating in total uncertainty. Learning to make these judgments is a capability that all humans require, because life forces us to make difficult decisions in every realm of our lives every day.

Because they are inherently personal, the arts provide a strong means for schools to activate and inspire students, to encourage self-motivation and discipline, and to help them discover the originality of their beings, the wonders and possibilities of life, the joys of learning, the satisfaction of achievement, and the revelations that literacy, broadly defined, provides. The arts are a central and fundamental means of attaining these objectives. The challenge is to carry a message to every superintendent, principal, school board member and parent to the effect that the arts should be an essential educational resource for every child in every school system. The educational potential of the arts is too great not to be fully exploited.

Name: _____

CHEATING OUR CHILDREN: WHY EVERY CHILD NEEDS THE ARTS *by Charles Fowler*

Review Questions

1. The article suggests there are seven ways that "engagement in the arts can contribute significantly and uniquely to personal development." Identify three of those ways and describe how they contributes to personal development.

2. In the article, the author quotes Charles Taylor, a professor of philosophy and political science, as he expresses the idea that individuals define their identity through dialogue and struggle with "the things our significant others see in us. Even after we outgrow some of these others—our parents, for instance—and they disappear from our lives, the conversation with them continues within us as long as we live." What do you think Taylor means when he says the conversation continues within us as long as we live? How does that conversation continue and what are we conversing about?

3. The article suggests that the arts help students to "learn to exist in a broadened horizon." What does the author mean by this statement?

4. In the article, the author states that "one of the reasons we read novels is that the characters in them are drawn sharply, clearly, and vividly. We can understand them in a way that is less possible in real life, and these revelations help us see all people and ourselves better." What does the author mean by this statement, and how might characters in a novel help us see all people and ourselves better?

5. How does the article suggest that the arts and science are similar?

6. What does the article mean by "the arts are symbol systems that enable us to represent our ideas, concepts, and feelings in a variety of forms that can be 'read' by other people"? Can you give an example that supports this statement?

7. The article suggests that the arts can expand consciousness. In what ways can the arts accomplish this? Can you offer an example? The article also suggests that the arts invite students to explore new meanings of themselves and the human condition. How do the arts accomplish this? Can you offer examples?

8. The author points out that antisocial behavior is more prevalent in schools that deprive students of arts instruction. After reading the article, discuss various ways the author suggests the arts help to keep students away from self-destructive, antisocial behavior?

9. In the article, the author states: "Of all the capacities of the human mind, imagination may be the most unusual and momentous." What is meant by this statement? Discuss in which ways it may be true.

10. The author says: "Through the creative process, students are forced to make judgments, and they necessarily develop a set of criteria by which to make them. They learn how to exercise judgment and how to justify their decisions." Discuss how individuals might apply these abilities to everyday life as working adults.

Research Topics

1. The author points out that some of humanity's deepest expressions of religious faith have been through the arts. Can you discover some examples that you find particularly moving or effective?

2. In the article, the author refers to the painting *Guernica* by Pablo Picasso. Research the historical events surrounding the creation of this work of art. Can you see how it relates to the events that inspired it?

3. Research another work of art, whether a painting, sculpture, piece of music, or literary work, that has war as its subject or inspiration. What do you find significant, engaging, or moving about that work of art?

WHY AMERICA'S OBSESSION WITH STEM EDUCATION IS DANGEROUS *By Fareed Zakaria*

Introduction

Fareed Zakaria is a respected journalist working for both *The Washington Post* and CNN. He is also the author of several best-selling books including *In Defense of a Liberal Education.* In this article, he addresses why he thinks all of the emphasis placed on the STEM (Science, Technology, Engineering, and Math) disciplines at the expense of the arts, humanities, and social sciences is detrimental to America's standing as a nation of innovators and entrepreneurs. He argues that technology and its STEM cousins are not enough, if relied on exclusively, to generate the future generations of great thinkers.

America's education history has been one of broad-based exposure to a multitude of disciplines and that has always been essential to American success in the world.

If Americans are united in any conviction these days, it is that we urgently need to shift the country's education toward the teaching of specific, technical skills. Every month, it seems, we hear about our children's bad test scores in math and science—and about new initiatives from companies, universities or foundations to expand STEM courses (science, technology, engineering and math) and deemphasize the humanities. From President Obama on down, public officials have cautioned against pursuing degrees like art history, which are seen as expensive luxuries in today's world. Republicans want to go several steps further and defund these kinds of majors. "Is it a vital interest of the state to have more anthropologists?" asked Florida's Gov. Rick Scott. "I don't think so." America's last bipartisan cause is this: A liberal education is irrelevant, and technical training is the new path forward. It is the only way, we are told, to ensure that Americans survive in an age defined by technology and shaped by global competition. The stakes could not be higher.

This dismissal of broad-based learning, however, comes from a fundamental misreading of the facts—and puts America on a dangerously narrow path for the future. The United States has led the world in economic dynamism, innovation and entrepreneurship thanks to exactly the kind of teaching we are now told to defenestrate. A broad general education helps foster critical thinking and creativity. Exposure to a variety of fields produces synergy and cross fertilization. Yes, science and technology are crucial components of this education, but so are English and philosophy. When unveiling a new edition of the iPad, Steve Jobs explained that "it's in Apple's DNA that technology alone is not enough—that it's technology married with liberal arts, married with the humanities, that yields us the result that makes our hearts sing."

Innovation is not simply a technical matter but rather one of understanding how people and societies work, what they need and want. America will not dominate the 21st century by making cheaper computer chips but instead by constantly reimagining how computers and other new technologies interact with human beings.

For most of its history, the United States was unique in offering a well-rounded education. In their comprehensive study, "The Race Between Education and Technology," Harvard's Claudia Goldin and Lawrence Katz point out that in the 19th century, countries like Britain, France and Germany educated only a few and put them through narrow programs designed to impart only the skills crucial to their professions. America, by contrast, provided mass general education because people were not rooted in specific locations with

long-established trades that offered the only paths forward for young men. And the American economy historically changed so quickly that the nature of work and the requirements for success tended to shift from one generation to the next. People didn't want to lock themselves into one professional guild or learn one specific skill for life.

That was appropriate in another era, the technologists argue, but it is dangerous in today's world. Look at where American kids stand compared with their peers abroad. The most recent international test, conducted in 2012, found that among the 34 members of the Organization for Economic Cooperation and Development, the United States ranked 27th in math, 20th in science and 17th in reading. If rankings across the three subjects are averaged, the United States comes in 21st, trailing nations such as the Czech Republic, Poland, Slovenia and Estonia.

In truth, though, the United States has never done well on international tests, and they are not good predictors of our national success. Since 1964, when the first such exam was administered to 13-year-olds in 12 countries, America has lagged behind its peers, rarely rising above the middle of the pack and doing particularly poorly in science and math. And yet over these past five decades, that same laggard country has dominated the world of science, technology, research and innovation.

Consider the same pattern in two other highly innovative countries, Sweden and Israel. Israel ranks first in the world in venture-capital investments as a percentage of GDP; the United States ranks second, and Sweden is sixth, ahead of Great Britain and Germany. These nations do well by most measures of innovation, such as research and development spending and the number of high-tech companies as a share of all public companies. Yet all three countries fare surprisingly poorly in the OECD test rankings. Sweden and Israel performed even worse than the United States on the 2012 assessment, landing overall at 28th and 29th, respectively, among the 34 most-developed economies.

But other than bad test-takers, their economies have a few important traits in common: They are flexible. Their work cultures are non-hierarchical and merit-based. All operate like young countries, with energy and dynamism. All three are open societies, happy to let in the world's ideas, goods and services. And people in all three nations are confident—a characteristic that can be measured. Despite ranking 27th and 30th in math, respectively, American and Israeli students came out at the top in their belief in their math abilities, if one tallies up their responses to survey questions about their skills. Sweden came in seventh, even though its math ranking was 28th.

Thirty years ago, William Bennett, the Reagan-era secretary of education, noticed this disparity between achievement and confidence and quipped, "This country is a lot better at teaching self-esteem than it is at teaching math." It's a funny line, but there is actually something powerful in the plucky confidence of American, Swedish and Israeli students. It allows them to challenge their elders, start companies, persist when others think they are wrong and pick themselves up when they fail. Too much confidence runs the risk of self-delusion, but the trait is an essential ingredient for entrepreneurship.

My point is not that it's good that American students fare poorly on these tests. It isn't. Asian countries like Japan and South Korea have benefitted enormously from having skilled workforces. But technical chops are just one ingredient needed for innovation and economic success. America overcomes its disadvantage—a less-technically-trained workforce—with other advantages such as creativity, critical thinking and an optimistic outlook. A country like Japan, by contrast, can't do as much with its well-trained workers because it lacks many of the factors that produce continuous innovation.

Americans should be careful before they try to mimic Asian educational systems, which are oriented around memorization and test-taking. I went through that kind of system. It has its strengths, but it's not conducive to thinking, problem solving or creativity. That's why most Asian countries, from Singapore to South Korea to India, are trying to add features of a liberal education to their systems. Jack Ma, the founder of China's Internet behemoth Alibaba, recently hypothesized in a speech that the Chinese are not as innovative as Westerners because China's educational system, which teaches the basics very well, does not nourish a student's complete intelligence, allowing her to range freely, experiment and enjoy herself while learning: "Many painters learn by having fun, many works [of art and literature] are the products of having fun. So, our entrepreneurs need to learn how to have fun, too."

No matter how strong your math and science skills are, you still need to know how to learn, think and even write. Jeff Bezos, the founder of Amazon (and the owner of this newspaper), insists that his senior executives write memos, often as long as six printed pages, and begins senior-management meetings with a period of quiet time, sometimes as long as 30 minutes, while everyone reads the "narratives" to themselves and makes notes on them. In an interview with Fortune's Adam Lashinsky, Bezos said: "Full sentences are harder to write. They have verbs. The paragraphs have topic sentences. There is no way to write a six-page, narratively structured memo and not have clear thinking."

Companies often prefer strong basics to narrow expertise. Andrew Benett, a management consultant, surveyed 100 business leaders and found that 84 of them said they would rather hire smart, passionate people, even if they didn't have the exact skills their companies needed.

Innovation in business has always involved insights beyond technology. Consider the case of Facebook. Mark Zuckerberg was a classic liberal arts student who also happened to be passionately interested in computers. He studied ancient Greek intensively in high school and majored in psychology while he attended college. And Facebook's innovations have a lot to do with psychology. Zuckerberg has often pointed out that before Facebook was created, most people shielded their identities on the Internet. It was a land of anonymity. Facebook's insight was that it could create a culture of real identities, where people would voluntarily expose themselves to their friends, and this would become a transformative platform. Of course, Zuckerberg understands computers deeply and uses great coders to put his ideas into practice, but as he has put it, Facebook is "as much psychology and sociology as it is technology."

Twenty years ago, tech companies might have survived simply as product manufacturers. Now they have to be on the cutting edge of design, marketing and social networking. You can make a sneaker equally well in many parts of the world, but you can't sell it for $300 unless you've built a story around it. The same is true for cars, clothes and coffee. The value added is in the brand—how it is imagined, presented, sold and sustained. Or consider America's vast entertainment industry, built around stories, songs, design and creativity. All of this requires skills far beyond the offerings of a narrow STEM curriculum.

Critical thinking is, in the end, the only way to protect American jobs. David Autor, the MIT economist who has most carefully studied the impact of technology and globalization on labor, writes that "human tasks that have proved most amenable to computerization are those that follow explicit, codifiable procedures—such as multiplication—where computers now vastly exceed human labor in speed, quality, accuracy, and cost efficiency. Tasks that have proved most vexing to automate are those that demand flexibility, judgment, and common sense—skills that we understand only tacitly—for example, developing a hypothesis or organizing a closet." In 2013, two Oxford scholars conducted a comprehensive study on employment and found that, for workers to avoid the computerization of their jobs, "they will have to acquire creative and social skills."

This doesn't in any way detract from the need for training in technology, but it does suggest that as we work with computers (which is really the future of all work), the most valuable skills will be the ones that are uniquely human, that computers cannot quite figure out—yet. And for those jobs, and that life, you could not do better than to follow your passion, engage with a breadth of material in both science and the humanities, and perhaps above all, study the human condition.

One final reason to value a liberal education lies in its roots. For most of human history, all education was skills-based. Hunters, farmers and warriors taught their young to hunt, farm and fight. But about 2,500 years ago, that changed in Greece, which began to experiment with a new form of government: democracy. This innovation in government required an innovation in education. Basic skills for sustenance were no longer sufficient. Citizens also had to learn how to manage their own societies and practice self-government. They still do.

Name: _____

WHY AMERICA'S OBSESSION WITH STEM EDUCATION IS DANGEROUS *by Fareed Zakaria*

Discussion Questions

1. Early in the article, the author states "This dismissal of broad-based learning, however, comes from a fundamental misreading of the facts – and puts America on a dangerously narrow path for the future." According to the article, what are some of those facts that are being misread?

2. In the article, the author states that a "broad general education helps foster" two things. What are those two things and how, according to the author, does a general education foster them?

3. The article mentions the word innovation a few times, one in context of Steve Jobs and Apple, another in context of Facebook and Mark Zuckerberg. In both those cases innovation is described as not being just about technology but something which also involves what other important factors?

4. Steve Jobs is also quoted as saying that Apple's DNA is not just about technology but also what two other things? What might it be about those additional factors that would make them important to Apple's DNA?

5. In the article, Zakaria suggests that "America overcomes its disadvantage—a less-technically-trained workforce—with other advantages... What are the advantages mentioned? Based on the article, how does a broad-based liberal arts education contribute to those advantages?

6. The article describes how Jeff Bezos, founder of Amazon.com, begins his senior-management meetings and what he expects of his senior executives. Discuss why he does this, what the benefits are to this approach, and what it indicates he expects out of his executives.

Research Topics

1. Jack Ma, founder of Alibaba, compares the education systems of China and the United States. Research how the two systems differ and discuss the pros and cons of both.

2. Consider any of the professional sports teams in any of the professional leagues with which you are familiar and research all aspects of how they function both on and off the field/ice/court etc. Ask yourself in what ways are creativity, critical thinking, sociology, and psychology put to use running those businesses.

CHAPTER 3

The Art of Making Theatre

A TRADITION OF THE THEATER AS ART *by David Mamet*

Introduction

In his article, playwright, director, and dramatic critic David Mamet discusses the purpose theatre serves in society and how that purpose is explored by the practitioners of the theatrical artform. He begins his exploration by addressing a common belief held by many in the theatre that the theatre is dying. He accepts this belief and then addresses what that actually means. Often, the practitioners of the theatre—producers, artistic directors, actors, and the like—can be heard bemoaning the fact that the theatre's audience is aging and dying off. They fear that the theatre will die with its audience. They argue that there are not enough youth in the audience to replenish the old and that the death of the audience is the death of the theatre as an artform. Mamet argues that, in fact, the opposite is true, that as with everything, the theatre also has its life cycles and that death is only a part of an ongoing process.

The title of the article itself says much about where he is coming from. In it, he acknowledges that there is a tradition to theatre, a tradition that extends so far back into the past, to the earliest times of human existence, that it would take an awfully momentous event to snuff out the tradition. He adds that the impulse and purpose behind the tradition is so fundamental to the human experience that it is not likely to be quashed any time soon and certainly not permanently, but that, as with all artforms, regeneration, rebirth, and self-examination are inherent to the theatre's continued existence.

We are told the theater is always dying. And it's true, and, rather than being decried, it should be understood. The theater is an expression of our dream life—of our unconscious aspirations.

It responds to that which is best, most troubled, most visionary in our society. As the society changes, the theater changes.

Our workers in the theater—actors, writers, directors, teachers—are drawn to it not out of intellectual predilection, but from *necessity*. We are driven into the theater by our need to express—our need to answer the questions of our lives—the questions of the time in which we live. Of this moment.

The theatrical artist serves the same function in society that dreams do in our subconscious life—the subconscious life of the individual. We are elected to supply the dreams of the body politic—we are the dream makers of the society.

What we act out, design, write, springs not from meaningless individual fancy, but from the soul of the times—that soul both observed by and expressed *in* the artist.

The artist is the advance explorer of the societal consciousness. As such, many times his first reports are disbelieved.

Later those reports may be acclaimed and then, perhaps, enshrined, which is to say sterilized—deemed descriptive not of an outward reality, but of the curious and idiosyncratic mental state of the artist. Later still the reports, and the artist, may be discarded as so commonplace as to be useless.

It is not the theater which is dying, but men and women—society. And as it dies a new group of explorers, artists, arises whose reports are disregarded, then enshrined, then disregarded.

The theater is always dying because artistic inspiration cannot be instilled—it can only be nurtured.

Most theatrical institutions survive creatively only for one generation. When the necessity which gave rise to them is gone, all that is left is the shell. The codification of a vision—which is no vision at all.

The artistic urge—the urge to create—becomes the institutional urge—the urge to *preserve*. The two are antithetical.

What can be preserved? What can be communicated from one generation to the next?

Philosophy. Morality. Aesthetics.

These can be expressed in technique, in those skills which enable the artist to respond truthfully, fully, lovingly to whatever he or she wishes to express.

These skills—the skills of the theater—cannot be communicated intellectually. They must be learned firsthand in long practice under the tutelage of someone who learned them firsthand. They must be learned from an artist.

The skills of the theater must be learned in practice with, and in emulation of, those capable of employing them.

This is what can and must be passed from one generation to the next. Technique—a knowledge of how to translate inchoate desire into clean action—into action capable of communicating itself to the audience.

This technique, this care, this love of precision, of cleanliness, this love of the theater, is the best way, for it is love of the *audience*—of that which *unites* the actor and the house: a desire to share something which they know to be true.

Without technique, which is to say without philosophy, acting cannot be art. And if it cannot be art, we are in serious trouble.

We live in an illiterate country. The mass media—the commercial theater included—pander to the low and the lowest of the low in the human experience. They, finally, debase us through the sheer weight of their mindlessness.

Every reiteration of the idea that *nothing matters* debases the human spirit.

Every reiteration of the idea that there is no drama in modern life, there is only dramatization, that there is no tragedy, there is only unexplained misfortune, debases us. It denies what we know to be true. In denying what we know, we are as a nation which cannot remember its dreams—like an unhappy person who cannot remember his dreams and so denies that he *does* dream, and denies that there are such things as dreams.

We are destroying ourselves by accepting our unhappiness.

We are destroying ourselves by endorsing an acceptance of oblivion in television, motion pictures, and the stage.

Who is going to speak up? Who is going to speak for the American spirit? For the human spirit?

Who is capable of being heard? Of being accepted? Of being believed? Only that person who speaks without ulterior motives, without hope of gain, without even the desire to *change*, with

only the desire to *create*: The artist. The actor. The strong, trained actor dedicated to the idea that the theater is the place we go to hear the truth, and equipped with the technical capacity to speak simply and clearly.

If we expect the actor, the theatrical artist, to have the strength to say no to television, to say no to that which debases, and to say yes to the stage—to that stage which is the proponent of the life of the soul—that actor is going to have to be trained, and endorsed, *concretely* for his efforts.

People cannot be expected to put aside even the meager comfort of financial success and critical acclaim (or the even more meager—and more widespread—comfort of the *hope* of those) unless they can be *shown* something *better*.

We must support each other *concretely* in the quest for artistic knowledge, in the struggle to create.

We must support each other in the things we say, in the things we choose to produce, in the things we choose to attend, in the things we choose to endow.

Only active choices on our parts will take theater, *true* theater, noncommercial theater, out of the realm of *good works*, and place it in the realm of art—an art whose benefits will cheer us, and will warm us, and will care for us, and elevate our soul out of these sorry times.

We have the opportunity now to *create* a new theater—and to endorse a *tradition* in theater, a tradition of true creation.

There is a story that a student once came to Evgeny Vakhtangov, an actor of the Moscow Art Theatre who founded his own studio to direct and to teach, and said, "Vakhtangov, you work so hard and with so little reward. You should have your own theater."

Vakhtangov replied, "You know who had his own theater? Anton Chekhov."

"Yes," the student said, "Chekhov had the Art Theatre, the Moscow Art Theatre."

"No," said Vakhtangov, "I mean that Chekhov had his *own* theater. The Theater which he carried in his heart, and which he alone saw."

Sanford Meisner's greatness is that for fifty years he has been training and preparing people to work in a theater which he alone saw—which existed only in his heart.

The results of his efforts are seen in the fact of the Neighborhood Playhouse School, the work of his students, and in the beginning of the Playhouse Repertory Company.

Many of us are here tonight in partial fulfillment of a debt to Mr. Meisner and more, importantly, to the same tradition to which he owes a debt—the tradition of Theater as Art.

The tradition of the theater as the place we can go to hear the truth.

Name: _____

A TRADITION OF THE THEATER AS ART
by David Mamet

Review Questions

1. This article explores the idea that the theatre is dying. In it, the author makes two statements that seem contradictory. He says that on the one hand, "it is not the theater which is dying, but men and women—society," and then on the other hand, "the theater is always dying because artistic inspiration cannot be instilled—it can only be nurtured." What does the author mean by the second statement that artistic inspiration cannot be instilled only nurtured, and how might the two statements be understood so that they are not, in fact, contradictory?

2. The author states, "the artistic urge—the urge to create—becomes the institutional urge—the urge to *preserve*," and notes that the two are antithetical. What is the distinction between the two urges, and why are they antithetical?

3. The author states, "We live in an illiterate country. The mass media—the commercial theatre included—pander to the low and the lowest of the low in the human experience." What does the author mean by pandering to the lowest of the low, and do you agree that we live in an illiterate country as he defines it?

4. What is meant by the author's last statement that "the theater [is] the place we go to hear the truth"?

Research Topics

1. The author quotes an anecdote about the actor/teacher Evgeny Vakhtangov, the Moscow Art Theatre, and the playwright Anton Chekhov. Who were Vakhtangov and Chekhov, and how important were they with regard to the art of making theatre? What was the Moscow Art Theatre, and what role did it play in the development of the art of making theatre—in Russia, the United States, and the rest of the world?

2. The author also refers to Sanford Meisner, the Neighborhood Playhouse School, and the Playhouse Repertory Company. Who was Sanford Meisner? How important was he with regard to the art of making theatre, and what role did the Neighborhood Playhouse School and the Playhouse Repertory Company serve in the development of the art of making theatre in the United States?

3. Early in the article, the author describes theatre artists as being "driven into the theater by our need to express—our need to answer the questions of our lives—the questions of the time in which we live." Who is the author and how does his work in the theatre contribute to answering the questions of our lives?

THE AUDIENCE *by Elmer Rice*

Introduction

In his article, playwright and director Elmer Rice discusses the purpose and function the audience serves in a theatrical performance and contemplates the power the theatre holds because it is capable of consistently drawing an audience. The old saying "if a tree falls in a forest . . ." applies aptly to the theatre and the audience. If there is no audience to hear and watch a play, can it be said to make any noise? Rice's musings attempt to answer this question.

Of all the factors that contribute to a complete theatrical performance, none is more necessary or important than the audience. For the dramatist has not succeeded in communicating the play he has created until an audience has assembled for the purpose of viewing it. The mere presence of an audience in a theatre is convincing evidence not only of the attractive power of enacted drama, but of the astonishing and unique human capacity for deliberate and voluntary self-discipline. Every time I go to see a play, I am struck afresh by the amount of social organization that is involved in the performance. Even passing over the construction and maintenance of the building itself, we find in the pattern of the production an amazing complex of personal relationships and co-ordinated skills. The more easily the performance flows, the more, we may be sure, it depends upon the split-second timing, the nicely balanced give-and-take and the unity of purpose of dramatist, actors, director, designer and technicians.

The audience is an even more amazing phenomenon. After all, the theatre workers are pursuing their chosen careers, and often their livelihood depends upon the success of their efforts. They have special reason, therefore, for concentration of their energies and for submission to discipline. But the members of an audience are under no such compulsion. For the most part, they are drawn to the theatre by nothing stronger than a desire for entertainment, using that word in its broadest sense. The reader picks up his book and puts it down at will, wherever he happens to be. The art lover wanders into the gallery at almost any hour of the day, and stays as long as he chooses Further, the reader takes his pleasures

in solitude; for the art lover a companion or two suffices.

Not so the theatergoer. At a very specific time, he must take himself at considerable expense and often at great physical inconvenience, to a specific place, to join a gathering of five hundred or a thousand fellow-theatregoers, nearly all strangers to him, and linked to him only by momentary similarity of purpose and willingness to submit to immobile captivity for the "two hours' traffic of our stage." Apart from this unity of purpose, the audience is almost certainly a heterogeneous assemblage indeed, composed of individuals varying widely in age, occupation, religion, race, education, intelligence and taste. The coming together of this motley gathering is both accidental and purposeful; ordinarily, neither its exact composition nor its exact response to the performance is predictable.

Yet this crowd, like any crowd, takes on an identity and a character of its own, which is not wholly like that of any of its component members. In certain respects everybody in the audience will react in the same way. For example, if the theatre is overheated, if the seats are too uncomfortable, if the actors are only half audible or half visible, nobody will enjoy the play, no matter what its merits. But in quite another category is the operation of the mores, those indefinable but very real criteria that somehow express the collective sense of what is fitting to be seen and heard in public. Obviously, there is a vast difference between private and public behavior; and people will be outraged to hear in a theatre the use of language and the mention of subjects which may be conversational commonplaces at their dinner

tables. When Clyde Fitch's play *The City* was posthumously produced, the general opinion was that it was not one of his best. Yet people flocked to see it apparently for the shock value of hearing. "God damn" spoken for the first time on the New York stage. At much less trouble and expense, they could have stood at any street corner and heard far stronger language used by the passers-by. Marc Connelly and I once speculated on what the audience reaction would be to a play in which the characters discussed their physical disabilities and hygienic problems in the manner familiar to the readers of advertisements in the mass-circulation magazines designed for "home" consumption.

Again, the moral judgments and intellectual concepts of the audience are likely to vary greatly from those of its individual members. An audience is almost certain to react hostilely to a character who is guilty of dishonesty, cruelty, non-comic drunkenness or non-comic marital infidelity, even though many of its members may not be entirely guiltless of one or more of these offenses. On the other hand, a *comic* treatment will evoke laughter even from those who have had painful experiences. Patriotic, pious and moral platitudes and clichés are often greeted in the theatre with approval and even applause by persons who would reject them in cold type or in private conversation. On the other hand, an audience may respond to poetic beauty or spiritual perception that is far above the general level of feeling or even of comprehension. Of course, the appeal of the theatre is primarily emotional rather than intellectual and the effect of a play is to increase sensitivity and to blunt the power of judgment. Theatregoers who read a play after seeing it often wonder why they were moved to laughter or to tears, or why they accepted situations or ideas that will not bear examination. (Sometimes they discover points that they missed in the theatre; but that is likely to be due to inattentiveness or to an inadequate performance.)

For me the most fascinating thing about an audience has always been the kind of gyroscopic balance it maintains between objectivity and participation. A play is most effective when the performance creates an illusion of reality so strong that it enables the audience to identify itself in some way with the characters and to share their joys, sorrows and perplexities. Yet this "voluntary suspension of disbelief" is never so complete that it destroys the audience's awareness that it is all pretense. It knows that the walls of the elegant salon are painted canvas, that the liquor that flows so freely is cold tea, that grandfather's beard is held in place with spirit gum, that the baby carried so tenderly is only a doll, that the falling snow is torn paper, that the lethal gun is loaded with blank cartridges, that the dead hero will arise in a moment to take his curtain call, and that the beautiful weeping heroine who kneels beside him has just divorced her third husband. Stated in these terms, the whole business of the theatre seems ridiculous. Yet it is not so, and the audience is only too glad to give itself up to the enjoyment of what it knows to be only make-believe. In fact, that is the very purpose for which it has come to the theatre. There is nothing more amazing than to see an audience that has been torn to shreds by the enactment of an emotional scene burst into thunderous applause the moment it is over, thus expressing acknowledgment of the skill of the actors, and perhaps of the dramatist, who have aroused it to this high pitch of excitement.

One of the best ways to judge the effect of a performance is to sit in a stage box, with one's back to the stage, and watch the audience. The changing expression of the faces and the movement of the bodies are a clear index to how the play is being received. "Sitting on the edges of their seats" is a literal description of audience behavior in moments of tension, and while "rolling in the aisles" is certainly figurative, it suggests the contortions of people who are in the throes of uncontrollable laughter. Smiles, tears, clenched hands, wide eyes all reflect the changing moods induced by the stage proceedings. Sexual allusions sometimes produce disapproving looks, sometimes self-conscious giggles or smirks; telling lines prompt an interchange of knowing looks between companions; and tender scenes are conducive to hand-holding. If there are coughs, yawns and restless squirmings you may be certain that the interest is slackening and that, for one reason or another, the contact between stage and auditorium has been broken. In fact, the nonrespiratory cough is an almost infallible danger signal: an attentive spectator does not cough.

Audiences are singularly obtuse about some things, singularly observant about others. Important information must usually be conveyed two or three times before it is fully grasped, as most dramatists are well aware. Yet frequently an audience will anticipate the point of a joke or the significance of a situation (as actors say: "They're way ahead of us") and after a performance or two,

lines that were carefully written and rehearsed are eliminated. Incredible happenings are sometimes readily accepted, while trivial flaws are instantly detected. I once saw an actor—obviously an understudy pressed into service at the last moment—read his entire part from various documents that he kept bringing forth. It was not until the last act that the audience became aware of what was going on. In *Counsellor-at-Law* there is a climactic scene near the end of the play which hinges on a telephone call. On the morning after the first preview at least twenty people called up to say that Paul Muni had dialed only six times instead of the required seven. No reader is very much disturbed by typographical errors or even the omission or repetition of a word. But very often an actor's mispronunciation of a word or the substitution of an incorrect one will break the mood of the audience or even produce a titter. A smudged collar, a protruding slip or a lipstick smear may provide a focus of attention that is fatally distracting. Actors almost invariably check their zippers before making an entrance. And any accident in the audience itself will destroy the spell: an explosive sneeze, an ill-timed guffaw, a drunken altercation, to say nothing of people suddenly bolting out of their seats and up the aisle, or having epileptic fits—not infrequent occurrences.

It is this element of audience participation and this constant interplay across the footlights—figuratively speaking, for footlights are almost obsolete—that keep the theatre boiling and give each performance a touch of adventuresomeness. For no two performances of any play are ever exactly alike. Audiences vary with season, the weather, the day of the week, the day's news. Any actor will tell you that Monday audiences are usually quiet; that Saturday-night audiences are relaxed and out for a good time; that Wednesday matinee audiences do not respond to humor but adore all the little homey touches; that benefit audiences are hard to please; that Sunday-night audiences are impervious to subtleties; and so on. These generalizations are undoubtedly a little too broad, but they are based upon long experience. And anyone who stands backstage during a performance is almost certain to hear an actor say, as he comes off: "They're laughing at anything tonight," or "They're sitting on their hands out there." Many times I have seen an actress almost in tears because she did not get the accustomed round of applause on her exit. The longer a play runs, the less perceptive is the audience. The reason is clear: the first audiences consist mainly of seasoned theatergoers, who are sophisticated and "theatre-wise" and therefore quick on the uptake. Audiences in which "out-of-towners" predominate are quite different from audiences of New Yorkers. If a play is a great success the audience is often "sold" on it well in advance. An actor in a great hit said to me: "You know, we used to wait for that first big laugh about two minutes after my entrance. Well, by the third week they began laughing the minute I came on. By the second month they laughed when the curtain went up. And after that, they were laughing as they came down the aisles to their seats." On the other hand, an audience may be oversold, and theatergoers who have waited months to see a play may find themselves disappointed in watching a tired performance, or hearing lines that have lost their luster through familiarity.

For the actor, as for any interpretive artist, the immediate response of the audience is of paramount importance. He has direct personal contact with it, in a way that no creative artist who does not also happen to be a performer can. His performance is necessarily ephemeral, forever wasted if it is not appreciated at the moment of execution. This is not to say that he finds no satisfaction in the characterization itself, which at its best demands the employment of imagination and many skills. But we have seen that of any artist expression is not enough; there must be communication too. And for the actor true communication exists only when he stands physically in the presence of an audience and wrests recognition from it by the display of his talents. That is why there are very few actors who do not prefer the stage to the television or motion-picture screen. Broadcasting and the movies may offer more security and greater financial rewards, but acting for a camera can never be the same as acting for an audience. Besides, a filmed performance is frozen and unalterable, whereas a stage performance is always fluid and vibrant, slightly modulated at each repetition to attune it to the mood of the audience, and having its minor defects, like the small irregularities that distinguish a bit of handicraft work from the smooth cold flawlessness of a factory job.

The dramatist, of course, has no such personal communion with the audience. When the curtain rises, he must depend upon the actors—and all his other associates in the production—to reveal what he has created. If he happens to be in the theatre during a performance he can

see and hear for himself how his work is being presented and how it is being received. He is elated when the play is going well, disheartened when it is going badly. But the fact that it is going at all represents the accomplishment of what he desired from the beginning: the communication to others of what he had expressed. The communication may be incomplete because of faulty expression, of feeble interpretation or of imperfect apprehension. But, for better or worse, he must have an audience. If there can be no drama without a theatre, then certainly there can be no theatre without an audience. The audience then is more than a mere passive recipient. In a vital, living theatre, the role of the audience is functional and creative.

Name: _____

THE AUDIENCE *by Elmer Rice*

Review Questions

1. In this article, the author states, "the audience . . . is more than a mere passive recipient. In a vital, living theatre, the role of the audience is functional and creative." Describe the ways in which an audience is functional and in what ways creative?

2. In the article, the author makes some *generalizations* about the audiences who attend performances on different days. Why do you suppose he says Monday audiences are "usually quiet"? Why would Wednesday matinee audiences "not respond to humor"?

3. The very first sentence of the article identifies the audience as the most "necessary or important" contributing factor of a theatrical performance. In what ways is this so?

4. According to the article, "the coming together of this motley gathering is both accidental and purposeful." In what ways does the author suggest is it accidental and in what ways purposeful?

5. What does Rice say about the similarities and differences of a theatre audience versus a movie audience or a ballet audience. Do you agree with his assessment?

HONOURING THE AUDIENCE *by Howard Barker*

Introduction

First published in 1988, "Honouring the audience" asks the fundamental question "What kind of audience do we want?" and then answers that question by suggesting that it is the responsibility of the theatre and its practitioners to develop the audience it wants. This essay, still equally applicable today, argues that the audience is a daring audience who would willingly embrace a challenge of uncomfortable experience if only given the opportunity.

Barker argues that the theatre lives in fear of its audience and giving in to that fear leads to a contemptuous treatment of the audience. This is done by providing it with an easy, handheld, propagandistic experience with simple answers. He argues that a "new" theatre is needed that will honor its audience by treating it not as a collective wanting to be fed but as a gathering of individuals eager for their own experience.

Obviously, the English theatre is in crisis. Equally obviously, its crisis reflects the crisis in the liberal intelligentsia which owns the theatre. This crisis is an intellectual one. The question, 'What kind of theatre do we want?' is best answered from the point of view of 'What kind of audience do we want?' We are in fear of our own audience, as a poor teacher is afraid of the class.

The word which has seeped into the vocabulary is Celebration. We do not know what to celebrate however, if only because at certain times there is nothing to celebrate. The theatre we have created celebrates nothing, though it is usually filled with laughter. Laughter appears to be a manifestation of solidarity, but it is now more often a sign of subordination. It is pain that the audience needs to experience, and not contempt. We have a theatre of contempt masquerading as comedy.

The liberal theatre wants to give messages. It has always wanted to give messages, it is its way of handling conscience. But no one believes the messages, even while they applaud them. We are in a profound contradiction when the audience claps what it no longer honestly believes.

It is always the case that the audience is willing to know more, and to endure more, than the dramatist or producer trusts it with. The audience has been treated as a child even by the best theatres. It has been led to the meaning, as if truth were a lunch. The theatre is not a disseminator of truth but a provider of versions. Its statements are provisional. In a time when nothing is clear, the inflicting of clarity is a stale arrogance.

A new theatre will not be ashamed of its complexity or the absence of ideology. It will feel no obligations to lived life or to the journalistic impulse to expose conditions. It will not be about conditions at all. A theatre of conditions is a profoundly reactionary one, just as the insistently ideological is also reactionary. Like a party poster with its jabbing finger, it impels you to tear it from the wall. A new theatre will not force anyone to be free. Rather it will be an invitation to ask what freedom is.

A new theatre will put its faith in the will to knowledge, not knowledge given by the knowing, but the individual will to knowledge which is elicited by the experience of contradiction in the theatre. The dramatist explores the terrain, half-knowing, half-ignorant. His journey is mapped by the actors. The audience participate in the struggle to make sense of the journey, which becomes their journey also. Consequently, what is achieved by them is achieved individually and not collectively. There is no official interpretation.

A theatre which honours its audience will not therefore make an icon of clarity. If a scene might mean two things it should not be reduced to one. If a speech contains its opposite it should be played for its opposites. This is not to say a new theatre will 'see both sides of the question', which is impotence and stagnation. It will rather emphasize the essential instability of character

and the untrustworthiness of opinion. We need a theatre of Anti-Parable, in which the moral is made by the audience and not by the actor. Naturally, this means the parable will be interpreted differently by different individuals. A good parable should provoke an argument and not a submissive nod of the head.

A theatre which honours its audience permits them to escape the nightmare of being entertained, to be left hungry, because theatre is not the providing of lunch. Until the theatre is seen as something other than a soup kitchen for the rich or a doss-house for the angry it will not be honoured in its turn, for the tramp is never grateful to the charity, any more than the plutocrat respects a waiter.

A theatre which honours its audience will demand of its writers that they write in hazard of their consciences, for writers are paid to think dangerously, they are the explorers of the imagination, the audience expects it of them. If they think safely, what is the virtue of them? Do you want to pay £10 to be told what you knew already? That is theft. Do you want to agree all the time? That is flattery, and the audience is always flattered, which is why it has become so sleek.

An honoured audience will quarrel with what it has seen, it will go home in a state of anger, not because it disapproves, but because it has been taken where it was reluctant to go. Thus morality is created in art, by exposure to pain and the illegitimate thought.

A new theatre will concede nothing to its audience, and the new audience will demand that nothing is conceded to it. It will demand the fullest expression of complexity, it will command the problem is exposed (but not solved). This new audience will demand more of the writers and the actor, and will itself set the pace of change. Only when the audience is insisting on change can the theatre be said to be in full flood. As things stand the audience is served, and its semiconscious applause is deemed success. But genuine success is the point at which the audience, in a state of supreme seriousness, demands to be pulled further into the problem.

A new theatre will be over-ambitious. It will not settle for anything less than a full company of actors. The stage should swarm with life. No new writer should be taught economy, no matter what the economy demands. The new writer should be shown that the stage is a relentless space and never a room. If the new writer is taught economy the theatre will itself shrink to the size of an attic. It is probably time to shut the studio theatres in the interests of the theatre.

It was once believed that the writer who wrote for himself would end up speaking to himself. It was believed the writer had to write for others, i.e. using accepted practices of listening and seeing. But only the writer who truly invents for himself will acquire the audience who hungers for his invention.

Name: _____

HONOURING THE AUDIENCE *by Howard Barker*

Discussion Questions

1. Early in the article, the author states that "the theatre is not a disseminator of truth but a provider of versions." What does the author mean by this?

2. Barker states that the "audience participate in the struggle to make sense of the journey." To what journey is he referring and why does the author suggest it is a struggle?

3. Given the context of the whole article and what Barker seems to suggest is the purpose of the theatre, what does he mean when he says "a theatre which honours its audience permits them to escape the nightmare of being entertained"? In what ways does he suggest being entertained is a nightmare?

4. Why, according to the author, should "no new writer . . . be taught economy"?

5. "A theatre which honours its audience will demand of its writers that they write in hazard of their consciences, for writers are paid to think dangerously." What does the author mean by this?

6. "An honoured audience will . . . go home in a state of anger." What does the author mean by this? In what ways does he suggest they be made angry and why would going home in this state honor them?

Research Topics

1. In this book are two articles focused on the audience. Discuss in detail how the two differ in their discussions of the audience. Are they contradictory in any way or are they complimentary?

2. At several points in the article the author discusses how the theatre he espouses would honor the audience. Choose one of those and discuss in detail in what way that particular point would in fact honor the audience. Then discuss how, by contrast, a theatre that does not fulfill that particular point does not honor its audience.

3. Select a play you have studied in class and discuss whether or not it honors the audience in the way that Barker suggests it should.

ARISTOTLE'S *POETICS* AND THE MODERN READER *by Francis Fergusson*

Introduction

The Greek dramatic critic Aristotle is perhaps the most influential writer of the theatre. His observations, theories, and ideas about the theatre and the artistry that goes into its creation are essential to anyone's understanding of the theatre. Based on his studies of the great Greek plays of Aeschylus, Sophocles, Euripides, and others, Aristotle set out to understand and describe what makes a great play and what makes a great production of a play. Francis Fergusson's incredible insights into the writings of Aristotle have done more to illuminate this great thinker's ideas than perhaps any other person.

In his analysis of the *Poetics*, Fergusson breaks down Aristotle's work into its component parts and investigates them, analyses them, and explains with great clarity and succinctness what Aristotle thought, believed, and advocated. He demonstrates the role the *Poetics* has played throughout the history of the theatre, and how it has influenced the practice and art of the theatre and its practitioners. He acknowledges many of the differences of interpretation scholars have had while studying the *Poetics*, while at the same time articulating his own interpretations.

For the novice to the study of the theatre, Fergusson's article is a great initiation into Aristotle's artistic philosophy, and for the more experienced theatre artist, it is a great launching point for a more concentrated study of the *Poetics*.

I. THE *POETICS* AND THE MODERN READER

The *Poetics*, short as it is, is the most fundamental study we have of the art of drama. It has been used again and again, since the text was recovered in the early Renaissance, as a guide to the techniques of play-making, and as the basis of various theories of drama. In our own time the great Marxist playwright, Bertolt Brecht, started with it in working out his own methods. He thought that all drama before him was constructed on Aristotle's principles, and that his own "epic drama" was the first strictly non-Aristotelian form.

When Aristotle wrote the *Poetics*, in the fourth century B.C., he had the Greek theater before his eyes, the first theater in our tradition. Perhaps that is why he could go straight to the basis of the dramatic art: he "got in on the ground floor." There is a majestic simplicity about the opening sentence, which we (in our more complex world) can only envy: "I propose to treat of Poetry in itself and of its various kinds, noting the essential quality of each. . . ." It still appears that, for tragedy at least, his favorite form, he did just that.

But the *Poetics* is not so simple for us as that sentence suggests. In the two thousand years of its life it has been lost, found again, and fought over by learned interpreters in every period. The modern reader, approaching it for the first time, may benefit from a little assistance.

The text itself is incomplete, repetitious in spots, and badly organized. It probably represents part of a set of lecture notes, with later interpolations.

In writing the *Poetics* Aristotle apparently assumed that his readers would know his own philosophy, and also the plays and poems he discusses. Certain key terms, like "action," "pathos," "form," can only be fully understood in the light of Aristotle's other writings. Moreover, his whole method is empirical: he starts with works of art that he knew well, and tries to see in them what the poet was aiming at, and how he put his play or poem together. He does not intend the *Poetics* to be an exact science, or even a textbook with strict laws, as the Renaissance

Introduction by Francis Fergusson from *Aristotle's Poetics*. Translated by S. H. Butcher. Introduction copyright © 1961 by Francis Fergusson. Reprinted by permission of Hill & Wang, a division of Farrar, Straus and Giroux, LLC.

humanists tried to make out with their famous "rules" of the unities of time, place, and action. He knew that every poet has his unique vision, and must therefore use the principles of his art in his own way. The *Poetics* is much more like a cookbook than it is like a textbook in elementary engineering.

The *Poetics* should therefore be read slowly, as an "aid to reflection"; only then does Aristotle's coherent conception of the art of drama emerge. In what follows I shall offer a short reading of this kind: bringing out the main course of his thought; pausing to see what he means by his notions of human psychology and conduct; and illustrating his artistic principles by actual plays. For the sake of convenience I shall use Sophocles' *Oedipus Rex*, Aristotle's own favorite tragedy, as my main illustration. But of course the art of drama is the matter in hand, and the more plays one analyzes in the light of Aristotle's principles, the better one understands the scope and value of the *Poetics*.

II. PRELIMINARY OBSERVATIONS ON POETRY AND OTHER ARTS (CHAPTERS I–V)

The opening chapters of the *Poetics* appear to be an introduction to a longer work (which has not survived) on the major forms of Poetry known to Aristotle, including comedy, epic, and dithyrambic poetry, as well as tragedy. The *Poetics* as it has come down to us, however, is devoted mainly to tragedy, and it is in Aristotle's analysis of that form that his general theory of art is most clearly illustrated. The first five chapters should be read, therefore, as a preliminary sketch which Aristotle will fill in when he gets down to business in Chapter VI.

Poets, like painters, musicians, and dancers, Aristotle says, all "imitate action" in their various ways. By "action" he means, not physical activity, but a movement-of-spirit, and by "imitation" he means, not superficial copying, but the representation of the countless forms which the life of the human spirit may take, in the media of the arts: musical sound, paint, word, or gesture. Aristotle does not discuss this idea here, for it was a commonplace, in his time, that the arts all (in some sense) imitate action.

The arts may be distinguished in three ways: according to the *object* imitated, the *medium* employed, and the *manner*. The object is always a particular action. The writer of tragedy (as we shall see) imitates a "serious and complete action"; the writer of comedy, one performed by characters who are "worse"—by which Aristotle may mean "sillier"—than the people we know in real life. By "medium" he simply means the poet's words, or the painter's colors, or the musician's sound. By "manner" he means something like "convention." Thus the manner of the writer of epics (or novels) is to represent the action in his own words; that of the playwright to represent it by what characters, acted on a stage, do and say. One may use the notions of object, medium, and manner still, to give a rough classification of the varied forms of poetry we know in our day.

In Chapter IV Aristotle briefly raises the question of the origin and development of poetry, which includes all the forms of literature and drama. He thinks it comes from two instincts in human nature itself, that of *imitation* and that of *harmony and rhythm*. The pleasure we get from the imitations of art is quite different from direct experience: it seems to come from *recognizing* what the artist is representing; some experience or vague intuition which suddenly seems familiar. It satisfies our need to know and understand; imitation has to do with the intellectual and moral content of art, and is therefore related to philosophy. Harmony and rhythm, on the other hand, refers to the pleasures of form which we usually consider "purely esthetic." It is characteristic of Aristotle to recognize both the content and the form of art.

After this short but suggestive passage, Aristotle sketches the historic development of the dithyramb, comedy, epic, and tragedy, in Greece. The passage is important, for it is the starting point of modern investigations of the sources of literature and the theater in our tradition, but Aristotle has, at this point, very little to say. It has been left to modern anthropologists and historians to fill in the details as well as they could. . . .

Aristotle did not have our interest in history, nor did he believe, as we often do, that the most primitive forms of human culture were the most significant. He thought that the only way to understand man, or his institutions, or his arts, was in their most fully developed, or "perfected" state. In the *Poetics* he seeks the highest forms of the art, and the masterpieces within each form, in order to see, in them, what poetry may be; and so

he is led to tragedy. "Whether Tragedy has as yet perfected its proper types or not . . . raises another question," he writes (IV. II); but tragedy was the form known to him which best fulfilled the aims of poetry, and most fully employed the resources of that art. He leaves room (in his usual cautious way) for the possible appearance of other forms; meanwhile he takes Greek tragedy, and especially Sophocles' masterpiece, *Oedipus Rex*, as his main instance of what poetry can be.

In Chapter V Aristotle begins a discussion of comedy, but this part is fragmentary, and not enough survives to tell us what he thought of that art. In Chapters XXIII and XXVI he discusses epic, but he thinks the principles of epic are only corollaries of those of tragedy, the more complete form. It is his analysis of tragedy, which begins in Chapter VI, that constitutes the main argument in the *Poetics*.

III. TRAGEDY: AN IMITATION OF AN ACTION

In Chapter VI.2, Aristotle starts his analysis of the art of tragedy with his famous definition:

> Tragedy, then, is an imitation of an action that is serious, complete, and of a certain magnitude; in language embellished with each kind of artistic ornament, the several kinds being found in separate parts of the play; in the form of action, not of narrative; through pity and fear of effecting the proper purgation of these emotions.

This definition is intended to describe tragedy, and also to distinguish it from other forms of poetry. Greek tragedy employed a verse form near to prose, like our English blank verse, for the dialogue, and elaborate lyric forms with musical accompaniment for the choruses; that is what Aristotle means by the different kinds of language. It is "in the form of action"—that is, it is acted on a stage—unlike epic, which is merely told by one voice. The "purgation of pity and fear" is Aristotle's description of the special *kind* of pleasure we get from tragedy.

The play itself, as we read it or see it performed, is the "imitation" of an action, and in what follows Aristotle devotes his attention, not to the action, but to the making of the play which represents an action. He is concerned with the *art* of tragedy; the phases of the poet's work of playmaking. The six "parts of Tragedy" which he discusses are, in fact, part of the poet's creative labor, and should be translated, "plot-*making*," "character *delineation*," and so forth. But before one can understand Aristotle's account of the poet's *art*, one must know what the art is trying to represent: the vision, or inspiration, which moves the poet to write or sing, i.e., the "action."

The Concept of "Action"; Action and Passion

Just after the definition of tragedy (VI.5) Aristotle tells us that action springs from two "natural causes," character and thought. A man's character disposes him to act in certain ways, but he *actually* acts only in response to the changing circumstances of his life, and it is his thought (or perception) that shows him what to seek and what to avoid in each situation. Thought and character together *make* his actions. This may serve to indicate the basic meaning of "action," but if one is to understand how the arts imitate action, one must explore the notion a little further.

One must be clear, first of all, that *action* (*praxis*) does not mean deeds, events, or physical activity: it means, rather, the motivation from which deeds spring. Butcher[1] puts it this way: "The *praxis* that art seeks to reproduce is mainly a psychic energy working outwards." It may be described metaphorically as the focus or movement of the psyche toward what seems good to it at the moment—a "movement-of-spirit," Dante calls it. When we try to define the actions of people we know, or of characters in plays, we usually do so in terms of motive. In the beginning of *Oedipus Rex*, for instance, Oedipus learns that the plague in Thebes is due to the anger of the gods, who are offended because the murderer of old King Laius was never found and punished. At that point Oedipus's action arises, i.e., his motive is formed: "to find the slayer." His action so defined continues, with many variations in response to changing situations, until he finds the slayer, who of course

[1] *Aristotle's Theory of Poetry and Fine Art*, by S. H. Butcher. 4th ed., London: Dover, 1932.

turns out to be himself. When Aristotle says "action" *(praxis)* in the *Poetics*, he usually means the whole working out of a motive to its end in success or failure.

Oedipus's action in most of the play is easy to define; his motive is a clear and rational purpose. That is the kind of action which Aristotle usually has in mind in discussing tragedy, and his word *praxis* connotes rational purpose. The common motive "to find the slayer" accounts for the main movement of *Oedipus Rex*; and most drama, which must be instantly intelligible to an audience, depends on such clearly defined motivation. But we know that human motivation is of many kinds, and in *Oedipus Rex*, or any great play, we can see that the characters are also moved by feelings they hardly understand, or respond to ideas or visions which are illusory. When one thinks of the other arts that imitate action, it is even more obvious that "rational purpose" will not cover all action: what kind of "movement-of-spirit" is represented in music, or painting, or lyric verse? "The unity of action," Coleridge wrote,[2] "is not properly a rule, but in itself the great end, not only of drama, but of the lyric, epic, even to the candle-flame of the epigram—not only of poetry, but of poesy in general, as the proper generic term inclusive of all the fine arts as its species." That is exactly Aristotle's view. He sees an action represented in every work of art, and the arts reflect not only rational purpose but movements-of-spirit of every kind.

In the *Poetics* Aristotle assumes, but does not explain, his more general concept of action. Thus when he writes (VI.9), "life consists in action, and its end is a mode of action," he is referring to the concept as explained in his writings on ethics. The word he uses there to cover any movement-of-spirit is *energeia*. In his studies of human conduct he speaks of three different forms of *energeia*, which he calls *praxis, poiesis,* and *theoria*. In *praxis* the motive is "to do" something; we have seen that Oedipus's action, as soon as he sees that he must find the slayer, is a *praxis*. In *poiesis* the motive is "to make" something; it is the action of artists when they are focused upon the play, or the song, or the poem, which they are trying to *make*. Our word "poetry" comes from this Greek word, and the *Poetics* itself is an analysis of the poet's action in making a tragedy. In *theoria* the motive is "to grasp

and understand" some truth. It may be translated as "contemplation," if one remembers that, for Aristotle, contemplation is intensely active. When he says (VI.9) that the end of life is a mode of action, he means *theoria*. He thought that "all men wish to know," and that the human spirit lives most fully and intensely in the perception of truth.

These three modes of action—doing, making, and contemplation—provide only a very rough classification of human actions, and Aristotle is well aware of that. For every action arises in a particular character, in response to the particular situation he perceives at that moment: every action has its own form or mode of being. Moreover, in Aristotle's psychology, both action and character (which he defines as *habitual action*) are formed out of ill-defined feelings and emotions, which he calls *pathos*. In any tragedy, which must represent a "complete action," the element of pathos is essential. If we are to understand the action in our example, *Oedipus Rex*, we must reflect upon the relationship between the pathos with which the play begins and ends, and the common purpose, to find the slayer, that produces the events of the story.

In Aristotle's philosophy, and in many subsequent theories of human conduct, the concepts "action" and "passion" (or *praxis* and *pathos*), are sharply contrasted. Action is active: the psyche perceives something it wants, and "moves" toward it. Passion is passive: the psyche suffers something it cannot control or understand, and "is moved" thereby. The two concepts, abstractly considered, are opposites; but in our human experience action and passion are always combined, and that fact is recognized in Aristotle's psychology. There is no movement of the psyche which is pure passion—totally devoid of purpose and understanding—except perhaps in some pathological states where the human quality is lost. And there is no human action without its component of ill-defined feeling or emotion; only God (in some Aristotelian philosophies) may be defined as Pure Act. When Aristotle says "life consists in action," he is thinking of action, in its countless forms, continually arising out of the more formless pathos (or "affectivity," as we call it) of the human psyche. Even in pain, lust, terror, or grief, the passion, as we know it, acquires some more or less conscious motive,

[2]In his essay on *Othello*.

some recognizably human form. That is why Aristotle can speak (XVIII.2) both of "pathetic" motivation, which is closer to the passionate pole of experience, and "ethical" motivation, which is closer to reason and the consciously controlled will.

With these considerations in mind, one can see more clearly what Aristotle means by the "complete action" which a tragedy represents. In the Prologue of *Oedipus Rex*, Thebes is suffering under the plague, and the Citizens beseech King Oedipus for help: the common purpose, "to cure Thebes," arises out of the passion of fear. When Creon brings the Oracle's word, the action is more sharply defined as "to find the slayer." Each Episode is a dispute between Oedipus and one of his antagonists about the quest for the slayer, and each one ends as the disputants fail to agree, and new facts are brought to light. The Chorus is left a prey to its fear again. The Choral Odes are "pathetic" in motivation, but their pathos, or passion, is given form through the continued effort *to see* how the common purpose might still be achieved. When Oedipus at last finds himself to be the culprit, his action is shattered, and even his character as an ethically responsible man along with it. The Chorus suffers with him; but through the laments and terrible visions of the end of the play, their action moves to *its* end: they see the culprit, and thereby the salvation of the city. Moreover, they see in self-blinded Oedipus a general truth of the human condition:

> Men of Thebes: look upon Oedipus.
>
> This is the king who solved the famous riddle
> And towered up, most powerful of men.
> No mortal eyes but looked on him with envy.
> Yet in the end ruin swept over him.
>
> Let every man in mankind's frailty
> Consider his last day; and let none
> Presume on his good fortune until he find
> Life, at his death, a memory without pain.[3]

This marks the end of the action in more ways than one. The common purpose has reached its paradoxical success, and the Chorus (and through it, the audience) has attained that mode of action, *theoria*, contemplation of the truth, which Aristotle regarded as the ultimate goal of a truly human life.

The complete action represented in *Oedipus Rex* is (fortunately for our purposes) easy to see. But all human actions which are worked out to the end, passing through the unforeseeable contingencies of a "world we never made," follow a similar course: the conscious purpose with which they start is redefined after each unforeseen contingency is suffered; and at the end, in the light of hindsight, we see the truth of what we have been doing. Mr. Kenneth Burke has used this "tragic rhythm of action," as he calls it, Purpose, to Passion, to Perception, in his illuminating analyses of various kinds of literature. All serious works of fiction or drama represent some complete action, even so complex a form as Shakespearean tragedy. In short, Aristotle's notion is useful still; for his lore of "action" is a kind of natural history of the psyche's life.

How Plot-Making Imitates the Action

Plot-making is in bad odor with contemporary critics of poetry, because they think of it as the mechanical ingenuity of whodunits and other "plotty" entertainments. Aristotle saw the usefulness of that kind of plot-making, and offers suggestions about how to do it; but his own primary conception of plot is "organic." He sees the plot as the basic *form* of the play, and in that sense one might speak of the "plot" of a short lyric.

But he is discussing the making of the plot of tragedy, and his first definition of it (VI.6) applies only to drama: "the arrangement of the incidents." This definition is very useful, as a beginning, because it enables one to distinguish the plot both from the story the poet wishes to dramatize, and from the action he wishes to represent.

The *story* of Oedipus was known to Sophocles as a mass of legendary material covering several generations. In making his *plot*, he selected only a few incidents to present onstage, and represented the rest through the testimony of Tiresias, Jocasta, the Messenger from Corinth, and the old Shepherd. The distinction between plot and story applies to all plays, including those whose story is invented by the poet. The story of an Ibsen play, for instance, might be told as a three-decker novel, but Ibsen always "arranges the incidents" in

[3] *The Oedipus Rex of Sophocles.* An English Version by Dudley Fitts and Robert Fitzgerald. (New York: Harcourt Brace Jovanovich, Inc., 1949.)

such a way as to show only a few crucial moments directly.

The purpose of plot-making is to represent one "complete action," in the case of *Oedipus Rex* the quest for the slayer which I have described. We must suppose that Sophocles saw a quest, a seeking motive, in the sprawling incidents of the Oedipus legend. That would be his poetic vision or "inspiration," the first clue to the play-to-be. He saw this action as tragic: as eventuating in destruction, suffering, and the appearance of a new insight. At that moment plot-making begins; the incidents of the story begin to fall into a significant arrangement.

"Plot, then," says Aristotle (VI.15), "is the first principle, and, as it were, the soul of a tragedy." This is the organic metaphor which is so useful in the analysis of a work of art. By "soul" Aristotle (who was a biologist) means the formative principle in any live thing whether man, animal, or plant. Consider an egg, for instance: it is only potentially a chicken until the "soul" within it, through the successive phases of embryonic development, makes it *actually* a chicken. Similarly, the action which the poet first glimpses is only potentially a tragedy, until his plot-making forms it into an *actual* tragedy. Aristotle thought that when the incidents of the story are arranged in their tragic sequence, they already produce some of the tragic effect, even though the characters are hardly more than names. That stage would correspond to the embryo when it is first recognizable as a chicken. But the chicken is not fully actual until it has plumage and a squawk, and the tragedy is not fully actual until all the dramatis personae are characterized, and all the language is formed to express their changing actions, moment by moment. The plot, in other words, is the "first" or basic form of the play, but it is by character delineation and the arts of language that the poet gives it the final form which we read, or see and hear.

The Parts of the Plot

A complete action (as we have seen) passes through the modes of purpose and pathos to the final perception, and the plot therefore has "parts"—types of incidents in the beginning, middle, and end of the play—resulting from the various modes of action. Aristotle discusses the parts of the plot in several ways, in connection with various playwriting problems.

In Chapter XII he lists and defines the "quantitative parts" of a tragedy, by which he means the sections (rather like the movements of a symphony) in which Greek tragedies were traditionally written: Prologue, Episode, Exode, and Choric song. This chapter is probably a late interpolation, and defective; but in the light of modern studies of the relation between tragedy and the ritual forms from which it was derived, it is important. The table on page 41 shows the "quantitative parts" of *Oedipus Rex* in relation to the action, and to the supposed form of the Dionysian ritual.

Aristotle devotes most of his attention to the "organic parts" of the plot, by which he apparently means those which represent a tragic action, and best serve to produce the specifically tragic effect. They all represent the action at the moment when it is reaching its catastrophic end: Reversal of the Situation, Recognition, and Pathos, which Butcher translates "Scene of Suffering." In the best tragedies, reversal, recognition, and pathos are inherent in the basic conception of the plot, and depend upon one another, as in *Oedipus Rex*.

"Reversal of the Situation," Aristotle says (XI.1), "is a change by which the action veers round to its opposite. . . . Thus in the *Oedipus*, the Messenger comes to cheer Oedipus and free him from his alarms about his mother, but by revealing who he is, he produces the opposite effect." Notice that the objective situation does not change, for Oedipus was, in fact, Jocasta's son all along. What changes is the situation as the thought of the characters makes it out at that moment; that is why Oedipus's action changes before our eyes. The action which seemed to be about to reach a happy end is seen to be headed for catastrophe, and Oedipus's final pathos follows.

"Recognition," Aristotle writes (XI.2), ". . . is a change from ignorance to knowledge." Oedipus's change from ignorance to knowledge occurs as he cross-questions the Messenger, and then the old Shepherd. By plotting this crucial moment in this way, Sophocles has, as it were, spread out before our eyes the whole turn of Oedipus's inner being, from the triumph which seems just ahead to utter despair. The tremendous excitement of this passage is partly due to the fact that what Oedipus "recognizes" is the reversal: "The best form of recognition is coincident with a Reversal of the Situation, as in the *Oedipus*," says Aristotle (XI.2). And it is due also to the fact that this moment of enlightenment was inherent in the whole

conception of the Tragic Plot: ". . . of all recognitions," says Aristotle (XVI.8), "the best is that which arises from the incidents themselves, where the startling discovery is made by natural means. Such is that in the *Oedipus* of Sophocles."

Aristotle offers the recognition scenes in *Oedipus* and in Sophocles' *Electra* (where the situation onstage turns from despair to triumph) as models of their kind. He also briefly analyzes other more mechanical and superficial ways of plotting the passage from ignorance to knowledge. He is certainly right in calling the recognition scene an "organic part" of the tragic plot, for in good drama down to our own day such scenes are essential to the tragic effect. Consider old Lear's gradual recognition of Cordelia, as he wakes in Act V; or Mrs. Alving's recognition of her son's mortal illness at the end of *Ghosts*. The action of perceiving, passing from ignorance to knowledge, is near the heart of tragedy, and the masters of that art all know how to "arrange the incidents" in such a way as to represent it on the stage.

Pathos also is an essential element in tragedy. We have seen that the whole action of *Oedipus Rex* arises out of the passion of fear; sinks back into pathos in each of the Choral Odes, and ends in the long sequence when the Chorus finally sees the meaning of Oedipus's suffering. Aristotle has little to say about plotting the "scene of suffering," perhaps because in Greek tragedy the element of pathos is usually represented in the musically accompanied verse of the Choral Odes. His most important point is in Chapter XIV.1: "Fear and Pity may be aroused by spectacular means; but they may also result from the inner structure of the piece. . . . He who hears the tale told will thrill with horror and melt to pity at what takes place. This is the impression we should receive from hearing the story of the *Oedipus*." When Oedipus yells in agony, when he appears with bleeding sockets for eyes, pathos is certainly represented by "spectacular means"; but by that moment in the play we understand Oedipus's plight so deeply that the sights and sounds are only symbols of the destruction of his inner being.

In discussing the "organic parts of the Plot" Aristotle has nothing to say about the Episodes. In *Oedipus Rex* the Episodes are the fierce disputes between Oedipus and his antagonists, whereby the quest for the slayer moves to its unforeseen end; they are essential in the unfolding of the story. Perhaps the text is again defective here, or it may be that Aristotle thought the Episodes less essential to the tragic effect than reversal, recognition, and pathos. However that may be, the inner structure of the Episodes, which are public debates, struggles of mind against mind, may best be considered under the heading of Thought and Diction, and I shall have something to say of them on page 75.

Kinds of Plots

Since the vision which the poet is trying to represent in his play is a certain action, there are various kinds of plot-making appropriate to the various kinds of action. The *Oedipus* is (in Aristotle's view) the best model: the action is "complete" and the plot represents it almost perfectly. The plot is "Complex," by which Aristotle means that it includes reversal and recognition, but there are "Simple Plots" which do not include these elements. The plot of *The Death of a Salesman*, for example, is simple, for poor Willy Loman proceeds straight down to his sordid end without ever passing from ignorance to knowledge. The action of *Oedipus Rex* takes the form of "ethical" motivation as Oedipus pursues his rational and morally responsible purpose of finding the slayer, as well as "pathetic" motivation at the beginning and end of the play. But Aristotle also recognizes plays of essentially pathetic motivation, and plays of essentially ethical motivation. In our time, Chekhov's plays are pathetic in motivation, and the plot, or basic form, is more like that of a lyric than that of traditional "drama." Ibsen's plays are mainly ethical in motivation, and consist chiefly of disputes like the Episodes in *Oedipus*.

Aristotle never forgets that a play must, by definition, hold and please an audience in the theater, and his whole discussion of plot-making is interspersed with practical suggestions for the playwright. The story must seem "probable," and Aristotle has canny recipes for making it seem so. The supernatural is hard to put over, and it is wiser to keep the gods off the stage. In Chapter XVIII.1, Aristotle points out that any plot may be divided into two main parts, the Complication, which extends from the prologue to the turning point, and the Unraveling or denouement, from the turning point to the end. This way of describing the structure of a plot will sound familiar to anyone who has learned the mechanics of the "well-made play." It is a useful formula for the practical

playwright, because it has to do, not with the dramatist's vision, but with the *means* of making any action clear and effective in the theater.

Aristotle's practical suggestions are still valuable, but they require no explanation, and I return to his main theory.

The Unity of the Play; Double Plots

The most fundamental question one can ask about any work of art is that of its unity: how do its parts cohere in order to make *one* beautiful object? Aristotle's answer, which he emphasizes again and again, is that a play or poem can be unified only if it represents *one action*. The poet, in building his form, conceiving his characters, writing his words, must make sure that everything embodies the one movement-of-spirit. That, as Coleridge says, is a counsel of perfection, "not properly a rule," but rather what all the arts aim at.

The plot of a play is the first form of the one action; what then are we to say of plays, like many of Shakespeare's, in which several plots, often taken from different stories, are combined?

Aristotle of course did not have Shakespeare's plays, but he did have Homer, who also combined many stories, many plot sequences, both in the *Iliad* and the *Odyssey*. And he recognized that Homer unified that more complex scheme by obeying the fundamental requirement of unity of action: (VIII.3): ". . . he made the *Odyssey*, and likewise the *Iliad*, to center round an action that in our sense of the word is one." Aristotle returns to this point in Chapter XXIII, where he takes up the epic. Lesser poets, he says, have tried to unify an epic by basing it upon one character, or one great historic event, like the Trojan War. Only Homer had the vision to discover one action in the wide and diversified material of his epics. The action of the *Iliad* (as the first lines suggest) is "to deal with the anger of Achilles." The action of the *Odyssey* is "to get home again," a nostalgic motive which we feel in Odysseus's wanderings, in Telemachus's wanderings, and in Penelope's patient struggle to save her home from the suitors. The interwoven stories, each with its plot, are analogous; and in the same way the stories which Shakespeare wove together to make a *Lear* or a *Hamlet* are analogous: varied embodiments of one action.

Aristotle did not think that tragedies plotted like the *Odyssey* with "a double thread of plot" (XIII.7) were the best tragedies. He preferred the stricter unity of the single plot and the single catastrophe. Perhaps if he had read *Lear* or *Hamlet* he would have modified this view. Even so, his principle of the unity of action is still the best way we have to describe the unity of a work of art, including the vast and complex ones with two or more plots.

How Character Delineation Imitates the Action

In Aristotle's diagrammatic account of play-making, the poet works on characterization after the action has been plotted as a tragic sequence of incidents. Characters are of course implicit from the first, since all actions are actions of individuals. But, as Aristotle reminds us again and again, ". . . tragedy is an imitation, not of men, but of an action and of life" (VI.9), and therefore "character comes in as subsidiary to the actions." The poet sees the action of the play-to-be first; then its tragic form (or plot), and then the characters best fitted to carry it out with variety and depth.

One must remember that in Aristotle's psychology, character is less fundamental than action. *Character* is defined as "habitual action," and it is formed by parents and other environmental influences out of the comparatively formless pathos (appetites, fears, and the like) which move the very young. As the growing person acquires habitual motives, he begins to understand them rationally, and so becomes ethically responsible: we say that he is a good or bad *character*. When we first meet Oedipus, he is a fully-formed character: a responsible ruler who (apparently in full awareness of what he is doing) adopts the rational motive of finding the slayer of Laius. But his discovery that he is himself the culprit destroys, not only his motive, but the "character" of knowing and responsible ruler; and passion, or pathos, takes over. Old Lear, at a similar point in his story, describes the experience accurately:

> O, how this mother swells up toward my heart!
> Hysterica passio! Down, thou climbing sorrow,
> Thy element's below.

After the catastrophes both Lear and Oedipus are "pathetically" motivated, like children, and like children ask for help and guidance. In tragedy, character is often destroyed; and at that moment we can glimpse "life and action" at a deeper level.

It is easy to see how the character of Oedipus, as imagined by Sophocles, is admirably fitted to represent the main action of the play, and carry it all the way to the end. With his intelligence, his arrogant self-confidence, and his moral courage, he is the perfect protagonist. But the other characters are almost equally effective for this purpose: Tiresias, who knows the will of the gods all along, but cannot himself take the lead in cleansing the city; or Jocasta, who obscurely fears the truth, and so feels that Thebes would be better off in ignorance. The contrasting characters reveal the main action in different ways, and their disagreements make the tense disputes of all the Episodes. But all this diversity of characterization, all this conflict of thought, is "with a view" to the action of the play as a whole: that common motive which I have said is "to save Thebes from its plague, by finding the unknown culprit."

It is, of course, by the plot that this main action, or common motive, is established. It is very clear in the Prologue, when everyone wants only to save Thebes. We forget it in the excitement of the disputes, and in the fascination of the contrasted characters; but we are reminded of it again in each Choral Ode. It is the Chorus which most directly represents the action of the *play*; and the Chorus can do that just because it has less "character" than Oedipus or his antagonists. In the Chorus we can sense the action at a deeper-than-individual level, and its successive Odes, with music and dance, mark the life and movement of the *play*.

We must suppose that the actions of Tiresias, Jocasta, even Oedipus, would be quite different if we saw them apart from the basic situation of the play—the plague in Thebes. We see them only in relation to that crisis, and that is why their actions, different though their characters are, are analogous. Aristotle has a good deal to say (VI.11 and 12) about less successful kinds of character delineation. Some of our "modern poets," he says, do not make effective characters, and so their works are devoid of ethical quality. Others develop character for its own sake—for local color, perhaps, or glamour, or amusement—thereby weakening the unity of the play, which can only be achieved when the action is one. In *Oedipus Rex* this problem is beautifully solved: the characters, sharply contrasted, are full of individual life and varied "ethical quality," yet the action of the *play* underlies them all.

Aristotle offers many other ideas about character delineation, based on his observation of the theater he knew, notably in Chapters XIII and XV. They are essentially practical rules of thumb, intended to assist the playwright to succeed with his audience, like his insistence on "probability" and consistency in characterization, or his notion that the tragic protagonist should usually be a ruler or leader. His observations are shrewd; but to be of assistance now they must be translated into terms of the modern theater.

How "Thought and Diction" Imitate the Action

In Chapter XIX Aristotle takes up "Thought" and "Diction" together, for they are both aspects of the language of the play. By *Diction*, he tells us, he means "the art of delivery": diction or speech as it is taught in modern schools of acting. Diction is one of the six parts of tragedy, for tragedy is by definition acted on a stage, and the actors must know how to handle its language. But Aristotle has little to say about it, because he is studying the art of the poet, who does not have to know how to speak as actors do.

Thought, however, concerns the poet directly, for thought is one of the "causes" of action. The poet works it out after the situations of the plot, and the characters, are clearly conceived. The word "thought" (*dianoia*) refers to a very wide range of the mind's activities, from abstract reasoning to the perception and formulation of emotion; for it is thought that defines all the objects of human motivation, whether they are dimly seen or clear and definite, illusory as dream, or objectively real. In the play, thought is represented by what the characters *say* about the course to be pursued, in each situation. That is why Aristotle identifies thought with the arts of language. "Under Thought," he says (XIX.2) "is included every effect which has to be produced by speech, the subdivisions being—proof and refutation; the excitation of the feelings, such as pity, fear, anger, and the like; the suggestion of importance or its opposite." At this point Aristotle refers us to his *Rhetoric*, where these modes of discourse are analyzed in detail.

In that work he writes (I.2), "Rhetoric may be defined as the faculty of observing in any given case the available means of persuasion. . . ." (Jowett's translation.) He is thinking primarily of a public speaker, a lawyer or statesman, whose action is "to persuade" his audience to adopt his opinion.

He considers the various means the speaker may use to persuade his audience: his attitudes, his use of voice and gesture, his pauses—in short, such means as actors use. But his main attention is devoted to arts of language, from the most logical (proof and refutation) where the appeal is to reason, to more highly colored language intended to move the feelings. The *Rhetoric* is an analysis of the forms of "Thought and Diction" which the action of persuading may take.

This analysis may be applied directly to the Episodes in *Oedipus*, i.e., to the thought-and-language of Oedipus and his antagonists, in the successive situations of the plot. They meet to debate a great public question, that of the welfare of Thebes; and they try to persuade not only one another, but the listening Chorus, and beyond that the frightened city. They are thus situated as Aristotle's user of rhetoric is, and they resort to the same arts of language. They begin with a show of reason ("proof and refutation"); but as this fails to persuade, they resort to more emotional language, and when that too fails the dispute is broken off in dismay.

Sophocles' Athenian audience, which was accustomed to the arts of public speaking, would presumably have enjoyed the skill of Oedipus and his antagonists. In modern drama we find neither the sophisticated formality of Greek tragedy, nor the rhetorical virtuosity which Aristotle analyzes. But the principles, both of tragedy and of classical rhetoric, are natural, and disputants in our day—politicians or mere amateur arguers—resort to rhetorical forms, whether they have ever heard of them or not. Disputing characters in all drama—especially drama of "ethical" motivation like Ibsen's—instinctively use the stratagems of rhetoric, as they try to overcome each other with thought-and-language. The structure of great scenes of conflict, in Neoclassic French drama, in Shakespeare, in Ibsen, is in this respect similar to that of the Episodes in *Oedipus*.

At this point the logic of Aristotle's scheme seems to require an analysis of the language of the Choral Odes which follow each Episode. In glossing his definition of tragedy he explains (VI.3), "By 'language embellished' I mean language into which rhythm, 'harmony,' and song enter"—which must refer to the Odes with their musical accompaniment. And he emphasizes the importance of the Chorus in the structure of the play (XVIII.7): "The Chorus too should be regarded as one of the actors: it should be an integral part of the whole, and share in the action, in the manner not of Euripides but of Sophocles." We know from his remark on *Mousiké*, which includes both music and lyric verse (in his *Politics*, VIII) that he thought the modes of *Mousiké* imitated the modes of action with singular directness and intimacy. But he does not analyze either music or the language of lyric poetry in any of his extant writings. Perhaps the relevant passages are lost, for the texts of both the *Politics* and the *Poetics* are incomplete.

One may, however, find the basis for an Aristotelian analysis of lyric language in some parts of the *Rhetoric*, and in Chapters XXI and XXII of the *Poetics*. I am thinking especially of his brief remarks on analogy and metaphor, which he regards as the basis of poetic language (XXII.9): "But the greatest thing by far is to have a command of metaphor. This alone cannot be imparted by another; it is the mark of genius, for to make good metaphors implies an eye for resemblances." His analysis of kinds of metaphors is dull, and he never demonstrates the coherent metaphors in a whole poem, as modern critics of lyric verse do; yet the basic conception is there. His definition of analogy is austere (XXI.6): "Analogy or proportion is when the second term is to the first as the fourth to the third. We may then use the fourth for the second, or the second for the fourth." But this conception of analogy has also proved fertile, far beyond what Aristotle could have foreseen. It is the basis of the subtle medieval lore of analogy, which underlies the poetry of Dante's *Divine Comedy*.

The Choral Odes in *Oedipus* may, like all lyrics, be analyzed in terms of metaphor and analogy. Take for example the first Strophe of the Parode, as translated by Fitts and Fitzgerald:

What is the god singing in his profound
Delphi of gold and shadow?
What oracle for Thebes, the sunwhipped city?

Fear unjoints me, the roots of my heart tremble.

Now I remember, O Healer, your power and wonder:
Will you send doom like a sudden cloud, or weave it
Like nightfall of the past?

Ah no: be merciful, issue of holy sound:
Dearest to our expectancy: be tender!

The main metaphors here are of light and darkness: "gold and shadow," "sunwhipped city," "sudden cloud," "nightfall of the past." In the rest of the Ode light and darkness appear in many other metaphors, and are associated with Apollo, the god of light, of healing, and also of disease; it was he who spoke through the Oracle of Delphi. The imagery of light and darkness runs through the whole play, stemming from Tiresias's blindness, and Oedipus's blindness at the end. It is based on the *analogy* between the eye of the body and the eye of the mind—sight:blindness::insight:ignorance. We may then, as Aristotle points out, use the fourth term (ignorance) for the second (blindness), and vice versa. Physical blindness and the darkness of nightfall express the seeking-action of the play, the movement-of-spirit from ignorance to insight. The Chorus "shares in the action," as Aristotle puts it. The Chorus cannot *do* anything to advance the quest, but as it suffers its passions of fear and pity it can grope through associated images of light and darkness, healing and disease, life and death, toward the perception of the truth.

It is not my intention, however, to attempt a full analysis of the poetic language of *Oedipus Rex*. I merely wish to suggest that, with the aid of the Aristotelian notions of metaphor and analogy, one can see how the Odes also imitate the action. The same principles apply to the poetic language of any good play, and the best modern critics (experts in the lyric) have made such analyses of the language of poetic drama, from Shakespeare to Yeats and Eliot.

Song and Spectacle; Action and Acting

The three basic parts of the art of tragedy are, as we have seen, plot-making, character delineation, and thought-and-language, for by these means the poet gives the action its tragic form, and its concrete actuality. The other three parts, *speech*, in the sense of the art of delivery, *song*, and *spectacle*, all have to do with the production of the play. They are thus essential to the art of tragedy, but concern the poet less directly than the other three, and Aristotle has little to say about them. He apparently did not feel qualified to discuss music and its performance (as one gathers from his remarks on *Mousiké* in *Politics*, VIII), and he seems to have had a low opinion of theatrical production in his time. When he wrote, the great dramatists were gone; and he seems to have known a

number of egoistic actors, like some of our modern stars, who made the plays into vehicles for their own personalities.

But Aristotle knew that the poet, in the very act of making his tragedy, had to be an actor. The poet does not need the techniques of voice, diction, and bodily movement, but he must, as he writes, imitate each character in his own inner being and "believe" the situations, just as a good actor does. For tragedy, as he says in his basic definition, is "in the form of actions," i.e., acted by characters. In Chapter XVII.1 and 2, he gives the poet some practical suggestions about achieving this essential quality:

> In constructing the plot and working it out with the proper diction, the poet should place the scene, as far as possible before his eyes. . . . Again, the poet should work out his play, to the best of his power, with appropriate gestures; for those who feel emotion are most convincing through natural sympathy with the characters they represent; and one who is agitated storms, one who is angry rages, with the most lifelike reality. Hence poetry implies either a happy gift of nature, or a strain of madness. In the one case a man can take the mold of any character; in the other, he is lifted out of his proper self.

The purpose of any good technique of acting is to help the actor to perceive the action of the character he is portraying, and then re-create it in his own thought and feeling, as Aristotle says the playwright must do. The best-known acting technique of this kind is that of the Moscow Art Theater, which is widely cultivated (in several versions) in this country. The late Jacques Copeau taught such a technique, and so did the best theater schools in Germany, before Hitler. Each school tends, unfortunately, to develop its own technical vocabulary, but I think their basic assumptions may all be expressed in Aristotelian terms. They all assume that the actor's art consists in "taking the mold" of the character to be portrayed, and then responding to the situations of the play as they appear to that character. Only in that way can the actor achieve "lifelike reality." Superficial mimicry cannot produce psychological truth, fidelity to the playwright's imagined people and situations, or emotional effect on the audience. The masters of acting technique have a subtle and practical lore of action. There is no

better way to understand "action," as that concept is used in Aristotle's *Poetics*, than by studying its practical utility in the art of acting.

IV. THE END OF TRAGEDY: PLEASURE, THE UNIVERSAL, AND THE PURGATION OF THE PASSIONS OF FEAR AND PITY

The question why tragedy, with its images of conflict, terror and suffering, should give us pleasure and satisfaction, has been answered in many ways. Aristotle's answers, cautious and descriptive as they are, have interested his readers more than anything else in the *Poetics*, and produced more heated controversies among his interpreters. The appeal of tragedy is in the last analysis inexplicable, rooted as it is in our mysterious human nature, but Aristotle's observations of the effect which tragedy has upon us are as illuminating as anything we have on the subject.

He accepted, to begin with, the Greek notion that the fine arts have no end beyond themselves. The useful arts, shipbuilding, carpentry, and the like, provide transportation or shelter, but a play or a symphony cannot be used for anything but "pleasure." And we have seen that in his introductory remarks Aristotle suggests that the arts give pleasure because they satisfy the instincts, or needs, of "imitation" and of "harmony" and "rhythm."

When we recognize the movement-of-spirit "imitated" in a play or poem, we get the satisfaction of knowledge and understanding. The joy of Romeo when he hears Juliet's voice saying his name, the despair of Macbeth when he sees that his mad race is lost, seem to confirm something we half-knew already. The creatures of the poet's imagination do not literally represent anything in our own experience; it must be that *through* word, character, and situation we glimpse something common to men in all times and places. That is why Aristotle writes, (IX.3): "Poetry . . . is a more philosophical and a higher thing than history: for poetry tends to express the universal, history the particular."

"Harmony and rhythm" must refer, not only to music, but to the accords and correspondences that we enjoy in any beautifully formed work of art. Stephen Daedalus, in Joyce's *Portrait of the Artist as a Young Man*, explaining his own Aristotelian conception of art, offers a general definition of rhythm: "Rhythm is the first formal esthetic relation of part to part in any esthetic whole or of an esthetic whole to its part or parts or of any part to the esthetic whole of which it is a part." Young Stephen's formula is laughably pedantic, but (if one thinks it out) extremely accurate. Stephen's whole discussion shows the right way to use Aristotle's ideas: as guides in one's own thinking about art.

Why do harmony and rhythm please us? We do not know; we can only note that they do. "There seems to be in us a sort of affinity to musical modes and rhythms," says Aristotle (*Politics*, VIII), "which makes some philosophers say that the soul is a tuning, others that it possesses tuning." The notion of the human psyche as itself a harmony and rhythm reappears again and again in our tradition, notably in Shakespeare, who often uses music to suggest the health of the inner being.

Such are the pleasures we find in all the fine arts; but the special quality of our pleasure in tragedy may be more closely defined. It comes, says Aristotle, from the purgation of the passions of fear and pity. At this point Stephen's meditations may help us again: "Aristotle has not defined pity and terror. I have. . . . Pity is the feeling which arrests the mind in the presence of whatsoever is grave and constant in human sufferings and unites it with the human sufferer. Terror is the feeling which arrests the mind in the presence of whatsoever is grave and constant in human sufferings and unites it with the secret cause." Notice that these passions must be stirred by the grave and *constant*. A particular calamity with no general meaning—a street accident for example—does not produce the tragic emotion; but only meaningless pain. Here we meet once more the universality of art: the passions of tragedy must spring from something of more than individual, more than momentary, significance. Moreover, the cause of our terror must be "secret." Tragedy, like the Dionysian ceremonies from which it was derived, touches the dark edge of human experience, celebrates a mystery of our nature and destiny.

It would seem (on thinking over the effects of a few tragedies) that pity and fear *together* are required. Pity alone is merely sentimental, like the shameless tears of soap opera. Fear alone, such as we get from a good thriller, merely makes us shift tensely to the edge of the seat and brace ourselves

for the pistol shot. But the masters of tragedy, like good cooks, mingle pity and fear in the right proportions. Having given us fear enough, they melt us with pity, purging us of our emotions, and reconciling us to our fate, because we understand it as the universal human lot.

Aristotle's word for this effect is "purgation" or "catharsis." The Greek word can mean either the cleansing of the body (a medical term) or the cleansing of the spirit (a religious term). Some interpreters are shocked by it, because they do not wish to associate poetry with laxatives and enemas; others insist that Aristotle had the religious meaning in mind. I think it is more sensible to assume that Aristotle did not mean either one *literally:* he was talking about tragedy, not medicine or religion, and his use of the term "purgation" is analogical. There are certainly bodily changes (in our chemistry, breathing, muscular tensions, and the like) as we undergo the emotions of tragedy, and they may well constitute a release *like* that of literal purgation. But tragedy speaks essentially to the mind and the spirit, and its effect is *like* that which believers get from religious ceremonies intended to cleanse the spirit. Aristotle noticed (Politics, VIII) that, in religious rituals that he knew, the passions were stirred, released, and at last appeased; and he must have been thinking partly of that when he used the term "purgation" to describe the effect of tragedy.

In the *Poetics* Aristotle does not try to show how the various effects which the art of tragedy aims at, as its "end," are united in an actual play. The pleasures of imitation, harmony, and rhythm; the universal quality of art, and the release and cleansing of the passions, are things he observed, and mentioned in different contexts. But we may, if we like, confirm them in any good tragedy. The effect of *Oedipus Rex*, for example, depends upon its subtle and manifold "rhythm" as Joyce defines the word; upon the pity and fear which are stirred in us, and upon our recognition, at the end, of something both mysterious and universal in Oedipus's fate. Aristotle had a consistent and far-reaching conception of the art of tragedy, and of its end; but his conception only emerges gradually as one thinks over his observations in the light of one's own experience of drama. . . .

Name: _____

ARISTOTLE'S *POETICS* AND THE MODERN READER
by Francis Fergusson

Review Questions

1. Early in the article, Francis Fergusson quotes Aristotle's definition of tragedy. In the definition Aristotle uses the phrase "in the form of action," by which, Fergusson says, he means "it is acted on a stage—unlike epic, which is merely told by one voice." A little further in the article, however, Fergusson goes on to discuss a different meaning of action (*praxis*). What is that meaning? How, according to Aristotle, is action created? How does *praxis* differ from *poiesis*? How does it differ from *theoria*?

2. According to Fergusson, Aristotle says that plot is the soul of a tragedy. What does Fergusson say Aristotle means when he uses the term *soul*? Do you agree that plot is the soul of a tragedy? What about other theatrical forms? Is it the soul of a comedy? Of a musical?

3. Fergusson discusses Aristotle's assertion that there are basic parts that form a plot. One of those parts is "recognition." He quotes Aristotle as saying, "recognition...is a change from ignorance to knowledge." They mean that the tragic hero must move from a place of ignorance to a place of knowledge or self-awareness, and that this occurs as part of the plot. Consider the tragedies and tragic heroes you have studied. Does each of the heroes experience this recognition? Can you identify what that recognition is in each hero?

4. The article discusses the difference between "complex" plots and "simple" plots. What is that difference?

5. According to the article, Aristotle has identified six basic parts to tragedy. Three have to do with the text itself and three have to do with the production. Can you identify the six and identify which ones have to do with text and which with production? Do some have to do with both text and production?

6. According to the article, what is the purpose of any good technique of acting? Is the purpose the same as that of the playwright? What about that of the designer and director?

7. The article discusses the appeal of tragedy and Aristotle's ruminations thereon. What are Aristotle's conclusions about the appeal of tragedy? What three instincts or needs does Aristotle say tragedy satisfies? Discuss what those three needs are and how tragedy satisfies them.

8. Do all interpreters of Aristotle's *Poetics* agree on its meanings? Based on your own experiences in the theatre, are there understandings, meanings, and interpretations in the article that you disagree with?

9. Fergusson discusses the different interpretations of Aristotle's word *catharsis* for the effect that tragedy has on the viewer. What does Fergusson himself say he believes Aristotle meant? How does he describe his interpretation of *catharsis*?

Research Topics

1. In discussing Aristotle's *Poetics,* Fergusson mentions the playwright Bertolt Brecht and how Brecht had started with the *Poetics* as he worked out his own methods. Who was Bertolt Brecht, and what were his "methods"? Fergusson refers to Brecht as a "Marxist" playwright. Do you agree with that categorization?

2. Fergusson says that Aristotle does not intend the *Poetics* to be an exact science, or even a textbook with strict laws, as the Renaissance humanists tried to make out with their famous "rules" of the unities of time, place, and action. Who were the "Renaissance humanists," and what were their rules of the unities of time, place, and action?

3. Fergusson says, "Tragedy, like the Dionysian ceremonies from which it was derived, touches the dark edge of human experience, celebrates a mystery of our nature and destiny." What were the Dionysian ceremonies to which he refers, and how do they touch the dark edge of human experience?

TRAGEDY AND THE COMMON MAN *by Arthur Miller*

Introduction

Arthur Miller is one of America's best known playwrights and author of what is arguably the best American play, *Death of a Salesman.* In his seminal essay, Miller argues for a reconceiving of what constitutes a tragic hero. Greatly influenced by 19th Century Norwegian playwright, Henrik Ibsen, Miller was intrigued by the tragic power of Ibsen's central characters and their middle-class background and wondered why they should be considered any less tragic than the larger-than-life heroes of Sophocles, Shakespeare, and their ilk.

What Miller explores is the once largely held notion that the heroes of tragedy must be someone of elevated social status, either royalty or nobility or at worst of the well-connected and his own contrary argument refuting this notion. Celebrating the figures of Ibsen's drama and the ordinary men and women around him in his everyday life, Miller argues in defense of the common man as a tragic figure.

With this article, Miller helped assure himself a lasting place in the history of world drama.

In this age few tragedies are written. It has often been held that the lack is due to a paucity of heroes among us, or else that modern man has had the blood drawn out of his organs of belief by the skepticism of science, and the heroic attack on life cannot feed on an attitude of reserve and circumspection. For one reason or another, we are often held to be below tragedy—or tragedy above us. The inevitable conclusion is, of course, that the tragic mode is archaic, fit only for the very highly placed, the kings or the kingly, and where this admission is not made in so many words it is most often implied.

I believe that the common man is as apt a subject for tragedy in its highest sense as kings were. On the face of it this ought to be obvious in the light of modern psychiatry, which bases its analysis upon classic formulations, such as Oedipus and Orestes complexes, for instances, which were enacted by royal beings, but which apply to everyone in similar emotional situations.

More simply, when the question of tragedy in art is not at issue, we never hesitate to attribute to the well-placed and the exalted the very same mental processes as the lowly. And finally, if the exaltation of tragic action were truly a property of the high-bred character alone, it is inconceivable that the mass of mankind should cherish tragedy above all other forms, let alone be capable of understanding it.

As a general rule, to which there may be exceptions unknown to me, I think the tragic feeling is evoked in us when we are in the presence of a character who is ready to lay down his life, if need be, to secure one thing-his sense of personal dignity. From Orestes to Hamlet, Medea to Macbeth, the underlying struggle is that of the individual attempting to gain his "rightful" position in his society.

Sometimes he is one who has been displaced from it, sometimes one who seeks to attain it for the first time, but the fateful wound from which the inevitable events spiral is the wound of indignity and its dominant force is indignation. Tragedy, then, is the consequence of a man's total compulsion to evaluate himself justly.

In the sense of having been initiated by the hero himself, the tale always reveals what has been called his "tragic flaw," a failing that is not peculiar to grand or elevated characters. Nor is it necessarily a weakness. The flaw, or crack in the character, is really nothing—and need be nothing—but his inherent unwillingness to remain passive in the face of what he conceives to be a challenge to his dignity, his image of his rightful status. Only the passive, only those who accept their lot without active retaliation, are "flawless." Most of us are in that category.

But there are among us today, as there always have been, those who act against the scheme of things that degrades them, and in the process of

action everything we have accepted out of fear of insensitivity or ignorance is shaken before us and examined, and from this total onslaught by an individual against the seemingly stable cosmos surrounding us—from this total examination of the "unchangeable" environment—comes the terror and the fear that is classically associated with tragedy. More important, from this total questioning of what has previously been unquestioned, we learn. And such a process is not beyond the common man. In revolutions around the world, these past thirty years, he has demonstrated again and again this inner dynamic of all tragedy.

Insistence upon the rank of the tragic hero, or the so-called nobility of his character, is really but a clinging to the outward forms of tragedy. If rank or nobility of character was indispensable, then it would follow that the problems of those with rank were the particular problems of tragedy. But surely the right of one monarch to capture the domain from another no longer raises our passions, nor are our concepts of justice what they were to the mind of an Elizabethan king.

The quality in such plays that does shake us, however, derives from the underlying fear of being displaced, the disaster inherent in being torn away from our chosen image of what and who we are in this world. Among us today this fear is strong, and perhaps stronger, than it ever was. In fact, it is the common man who knows this fear best.

Now, if it is true that tragedy is the consequence of a man's total compulsion to evaluate himself justly, his destruction in the attempt posits a wrong or an evil in his environment. And this is precisely the morality of tragedy and its lesson. The discovery of the moral law, which is what the enlightenment of tragedy consists of, is not the discovery of some abstract or metaphysical quantity.

The tragic right is a condition of life, a condition in which the human personality is able to flower and realize itself. The wrong is the condition which suppresses man, perverts the flowing out of his love and creative instinct. Tragedy enlightens-and it must, in that it points the heroic finger at the enemy of man's freedom. The thrust for freedom is the quality in tragedy which exalts. The revolutionary questioning of the stable environment is what terrifies. In no way is the common man debarred from such thoughts or such actions.

Seen in this light, our lack of tragedy may be partially accounted for by the turn which modern literature has taken toward the purely psychiatric view of life, or the purely sociological. If all our miseries, our indignities, are born and bred within our minds, then all action, let alone the heroic action, is obviously impossible.

And if society alone is responsible for the cramping of our lives, then the protagonist must needs be so pure and faultless as to force us to deny his validity as a character. From neither of these views can tragedy derive, simply because neither represents a balanced concept of life. Above all else, tragedy requires the finest appreciation by the writer of cause and effect.

No tragedy can therefore come about when its author fears to question absolutely everything, when he regards any institution, habit or custom as being either everlasting, immutable or inevitable. In the tragic view the need of man to wholly realize himself is the only fixed star, and whatever it is that hedges his nature and lowers it is ripe for attack and examination. Which is not to say that tragedy must preach revolution.

The Greeks could probe the very heavenly origin of their ways and return to confirm the rightness of laws. And Job could face God in anger, demanding his right and end in submission. But for a moment everything is in suspension, nothing is accepted, and in this sketching and tearing apart of the cosmos, in the very action of so doing, the character gains "size," the tragic stature which is spuriously attached to the royal or the high born in our minds. The commonest of men may take on that stature to the extent of his willingness to throw all he has into the contest, the battle to secure his rightful place in the world.

There is a misconception of tragedy with which I have been struck in review after review, and in many conversations with writers and readers alike. It is the idea that tragedy is of necessity allied to pessimism. Even the dictionary says nothing more about the word than that it means a story with a sad or unhappy ending. This impression is so firmly fixed that I almost hesitate to claim that in truth tragedy implies more optimism in its author than does comedy, and that its final result ought to be the reinforcement of the onlooker's brightest opinions of the human animal.

For, if it is true to say that in essence the tragic hero is intent upon claiming his whole due as a personality, and if this struggle must be total and without reservation, then it automatically demonstrates the indestructible will of man to achieve his humanity.

The possibility of victory must be there in tragedy. Where pathos rules, where pathos is finally derived, a character has fought a battle he could not possibly have won. The pathetic is achieved when the protagonist is, by virtue of his witlessness, his insensitivity, or the very air he gives off, incapable of grappling with a much superior force.

Pathos truly is the mode for the pessimist. But tragedy requires a nicer balance between what is possible and what is impossible. And it is curious, although edifying, that the plays we revere, century after century, are the tragedies. In them, and in them alone, lies the belief—optimistic, if you will, in the perfectibility of man.

It is time, I think, that we who are without kings, took up this bright thread of our history and followed it to the only place it can possibly lead in our time—the heart and spirit of the average man.

Name: _____

TRAGEDY AND THE COMMON MAN *by Arthur Miller*

Discussion Questions

1. Early in this article, the author, Arthur Miller, suggests that the "tragic feeling is evoked in us when . . . a character . . . is ready to lay down his life . . . to secure . . . his personal sense of dignity." What does Miller suggest a character is attempting to do by laying down his life and how might he achieve personal dignity in that way?

2. Arthur Miller has a very different understanding of the term *tragic flaw* than that which is commonly attributed to Aristotle. What does Miller suggest tragic flaw is and how does his definition differ from Aristotle's?

3. During the article, Miller says "it is the common man who knows this fear best." To what fear is he referring and why is it that the common man would know it best??

4. Miller, late in the article, discusses a "misconception of tragedy." What is that misconception?

5. Miller ends his article with the idea that "it is time . . . that we who are without kings" take up and follow our history to "the heart and spirit of the average man." What does he mean by this?

Research Topics

1. Compare the tragic flaws of a hero from a classic Greek tragedy, say Oedipus or Kreon, or of a Shakespearean hero, say Macbeth or Lear, and that of a Miller tragedy, say Willy Loman or John Proctor. In what ways are they similar and in what ways are they different? Argue whether you feel Miller is right or wrong with regards to the degree of tragic impact the heroes from the two genres have on an audience and, therefore, their respective validity as tragic heroes.

2. Consider a Miller tragic hero such as John Proctor from *The Crucible* or Willy Loman from *Death of a Salesman* and discuss how they each attempt to "secure their rightful place in society" and how, through their actions, they do or do not attain a "personal sense of dignity."

3. Imagine a circumstance where you might "lay down your life" to achieve a sense of dignity, describe the circumstance, and discuss whether or not you would consider such a circumstance and the outcome worthy of being called a tragedy in the traditional sense?

FORTYNINE ASIDES FOR A TRAGIC THEATRE
by Howard Barker

Introduction

As a champion of radical theatre, Howard Barker is an artist who challenges the current theatrical establishment and through his writings and opinions advocates for a new artistry of the theatre with new forms of theatrical expression. "Fortynine Asides for a Tragic Theatre" is included here because in many ways it serves as a sort of mini-manifesto, a capsule expression of many of his ideas. In it he questions the purpose of art, theatre, politics, artists, politicians, the audience, and society at large. He suggests that today's theatre is enslaved and that its enslavement is choking it of its most fundamental purpose. He challenges the preconceived notions of mainstream theatre, including those that the audience only wants to be entertained, that playwrights, directors, and actors should be considered founts of knowledge, or that plays should be free of ambiguity and presented so as to be easily understood.

In "Fortynine Asides for a Tragic Theatre," Barker discusses specifically the tragic form. He contrasts it with other theatrical forms and argues the function each has in society. He says: "Tragedy offends the sensibilities. It drags the unconscious into the public place. It therefore silences the banging of the tambourine which characterizes the authoritarian and the labourist culture alike." Through his invocations of tragedy, he recalls the spirit of the ancient Greeks and reminds us that tragedy, at its best, is purgative and restorative.

We are living the extinction of official socialism. When the opposition loses its politics, it must root in art.

The time for satire is ended. Nothing can be satirized in the authoritarian state. It is culture reduced to playing the spoons. The stockbroker laughs, and the satirist plays the spoons.

The authoritarian art form is the musical.

The accountant is the new censor. The accountant claps his hands at the full theatre. The official socialist also hankers for the full theatre. But full for what?

In an age of populism, the progressive artist is the artist who is not afraid of silence.

The baying of an audience in pursuit of unity is a sound of despair.

In a bad time laughter is a rattle of fear.

How hard it is to sit in a silent theatre.

There is silence and silence. Like the colour black, there are colours within silence.

The silence of compulsion is the greatest achievement of the actor and the dramatist.

We must overcome the urge to do things in unison. To chant together, to hum banal tunes together, is not collectivity.

A carnival is not a revolution.

After the carnival, after the removal of the masks, you are precisely who you were before. After the tragedy, you are not certain who you are.

Ideology is the outcome of pain.

Some people want to know pain. There is no truth on the cheap.

There are more people in pursuit of knowledge than the accountants will admit.

There is always the possibility of an avalanche of truth-seekers.

Art is a problem. The man or woman who exposes himself to art exposes himself to another problem.

It is an error typical of the accountant to think there is no audience for the problem.

Some people want to grow in their souls.

But not all people. Consequently, tragedy is elitist.

Because you cannot address everybody; you may as well address the impatient.

The opposition in art has nothing but the quality of its imagination.

The only possible resistance to a culture of banality is quality.

Because they try to debase language, the voice of the actor becomes an instrument of revolt.

The actor is both the greatest resource of freedom and the subtlest instrument of repression.

If language is restored to the actor he ruptures the imaginative blockade of the culture. If he speaks banality he piles up servitude.

Tragedy liberates language from banality. It returns poetry to speech.

Tragedy is not about reconciliation. Consequently, it is the art form for our time.

Tragedy resists the trivialization of experience, which is the project of the authoritarian regime.

People will endure anything for a grain of truth.

But not all people. Therefore a tragic theatre will be elitist.

Tragedy was impossible as long as hope was confused with comfort. Suddenly tragedy is possible again.

When a child fell under a bus they called it a tragedy. On the contrary, it was an accident. We have had a drama of accidents masquerading as tragedy.

The tragedies of the 1960s were not tragedies but failures of the social services.

The theatre must start to take its audience seriously. It must stop telling them stories they can understand.

It is not to insult an audience to offer it ambiguity.

The narrative form is dying in our hands.

In tragedy, the audience is disunited. It sits alone. It suffers alone.

In the endless drizzle of false collectivity, tragedy restores pain to the individual.

You emerge from tragedy equipped against lies. After the musical, you are anyone's fool.

Tragedy offends the sensibilities. It drags the unconscious into the public place. It therefore silences the banging of the tambourine which characterizes the authoritarian and the labourist culture alike.

It dares to be beautiful. Who talks of beauty in the theatre any more? They think it is to do with the costumes.

Beauty, which is possible only in tragedy, subverts the lie of human squalor which lies at the heart of the new authoritarianism.

When society is officially philistine, the complexity of tragedy becomes a source of resistance.

Because they have bled life out of the word freedom, the word justice attains a new significance. Only tragedy makes justice its preoccupation.

Since no art form generates action, the most appropriate art for a culture on the edge of extinction is one that stimulates pain.

The issues are never too complex for expression.

It is never too late to forestall the death of Europe.

Name: _____

FORTYNINE ASIDES FOR A TRAGIC THEATRE
by Howard Barker

Review Questions

1. The very first sentence of "Fortynine Asides for a Tragic Theatre" states, "We are living the extinction of official socialism. When the opposition loses its politics, it must root in art." What does Barker mean when he says we are living the extinction of official socialism and that the politics of the opposition must root in art? Who is the opposition and is this the role art is supposed to play?

2. "Fortynine Asides for a Tragic Theatre" states, "the authoritarian art form is the musical." What does the author mean by this? Do you agree? Why?

3. "Fortynine Asides for a Tragic Theatre" states, "After the tragedy, you are not certain who you are." What does the author mean by this? Think back to an experience you have had watching a tragedy; can you understand what the author might be suggesting? Try to defend his statement, and then try to refute it.

4. "Fortynine Asides for a Tragic Theatre" states, "Art is a problem. The man or woman who exposes himself to art exposes himself to another problem. It is an error typical of the accountant to think there is no audience for the problem." Given what the author says about "the accountant" earlier in the article, what does he mean by this statement? Is there an audience for the problem? What does he mean that art is a problem?

5. Twice the article says that tragedy either is or will be elitist. In what ways does the author equate tragedy with elitism? Do you agree with the author? Is art that is elitist a bad thing or a good thing?

6. "Fortynine Asides for a Tragic Theatre" states, "The theatre must start to take its audience seriously. It must stop telling them stories they can understand." What does the author mean by this? In what ways is he suggesting that the theatre not take its audience seriously? Why does he imply that plays that are easily understood insult the audience?

7. The author states that tragedy offends the sensibilities. How does it do this? Is this a good or bad thing?

8. Select one statement from the article with which you agree and that is not referenced in these Review Questions and explain why you agree with it.

9. Select one statement from the article with which you disagree and that is not referenced in these Review Questions and explain why you disagree with it.

Research Topics

1. Who is Howard Barker? Besides the three articles contained in this book, has he written anything else? If so, read something of his and discuss it.

2. Identify ten words in the article you don't know—define them and discuss them.

ON LANGUAGE IN DRAMA *by Howard Barker*

Introduction

As in "Fortynine Asides for a Tragic Theatre," Barker addresses one of the many accepted notions of contemporary theatre—that of theatre's responsibility to depict life as it is. He argues that this trend toward naturalism, which has dominated theatre production and writing for the better part of a century now, robs the theatre of its imagination, and that defending language on the basis of naturalism also inherently guarantees limitations on imagination. So, he argues against the idea of legitimizing obscenity on the stage by pronouncing it as authentic to the current vernacular. Rather, he defends the use of obscenity as a tool of communication necessary to give emotion its full range and depth and give an idea its full compass. He discusses the notion of censoring language and the purpose censorship serves. He says, "language is the means by which emotion is conveyed . . . [and that] because of the responsibility of drama to emotional truth . . . words cannot simply be abolished."

Once again, as in everything he writes, the author presents provocative ideas that are as applicable to the theatre as they are to all forms of artistic expression.

I would like to discard at the beginning of this paper any argument about drama's responsibilities towards naturalism or what passes for authentic speech. The defence of obscenity on the grounds that it is prevalent in the street is not one which interests me or seems specially legitimate. I have never been interested in reported speech or the reproduction of authentic voices. Only those writers and producers who claim to reflect life-as-it-is-lived are saddled with the contradiction of deleting expletives and sexual nouns whilst claiming to address people in their own tongue.

I would prefer rather to make a few points about the dramatist's responsibility to a higher truth than mere authenticity. The drama which I practice creates its own world, it does not require validation from external sources, either of ideology or of spurious realism, which is itself an ideology. It is compellingly imaginative and without responsibility to historical or political convention. The audience is made aware of this very rapidly—within a scene or two it is invited to discard its normal assumptions about the manner in which reality is reproduced. What is signaled is the appearance of different dramatic values and what is witnessed is not the reiteration of common knowledge but a dislocation of perceptions—in other words, it is engaging with a work of art in which the normal criteria of offence and empathy are abolished. I would stress that this is nothing at all to do with entertainment, which is perfectly able to operate within a limited vocabulary for the simple reason that it operates within a limited range of emotions. A tragic drama exposes the entire range of human emotions and attempts to extend it, and it entails an obligation to explore, describe and speculate on all areas of human experience. Language is the means by which emotion is conveyed—in radio almost entirely so—and the two or three words we are so often exercised about are among the most highly charged in the vocabulary. Because of the responsibility of drama to emotional truth, these words cannot simply be abolished. The bland question so often put to writers, 'Do you really need those words?' rings with a false innocence. The hidden meaning of this question is 'Do you really need those feelings?' and attempts to restrict vocabulary are invariably attempts to restrict emotion. The words are irreplaceable for the reason that they are charged with a combined fear and longing. It is not for nothing that the word 'cunt' operates both as the most extreme notation of abuse and also the furtherest reach of desire, and not only in male speech, and in attempting to eliminate the word the thing itself is eliminated, since nothing can stand in for it. Since what cannot be expressed cannot exist dramatically, the attempt to abolish the word becomes an attack

on the body itself—a veiled attempt to remove the body from dramatic space. The debate about words becomes a debate about the body, who owns it, and who describes it, and if the words are forbidden to the artist, the body reverts to the doctor. I would suggest that the aim of the language censor is to return the body to the biology class where eroticism is displaced and desire corrupted into a squalid fetishism. Furthermore, I would propose that those who seek to inhibit emotion in drama through the concept of obscenity betray a contempt for the audience. The false notion of a guardianship of values is in effect a bid for moral engineering.

I am a writer who has made and still does make conscious use of words conventionally described as obscene. I use them with calculation and discrimination for their dramatic effect. I place the words in the mouths of certain characters some-times abusively, sometimes erotically, and some-times with calculated excess, and always with the deliberate intention of creating the unease in the audience which is for me the condition of experiencing tragedy, an unease which is at the opposite pole from the apathy an audience feels in a state of entertainment. Drama, as I suggested above, is not life described but life imagined, it is possibility and not reproduction. The idea of obscenity is related to shame, and shame can be both employed and overcome by the fullest commitment of the actor and writer to the emotion described, to its validity and truth, and where this occurs the initial frisson of discomfort experienced by the audience in the presence of an actor arguing the body is replaced by an awe for the powers of human emotion. In this way the obscenity becomes a ground for moral revaluation.

Name: _____

ON LANGUAGE IN DRAMA *by Howard Barker*

Review Questions

1. In "On Language and Drama," the author discusses his beliefs of the "dramatist's responsibility to a higher truth than mere authenticity." What does he mean by this?

2. According to the author, what purpose should language serve in drama?

3. According to the author, what purpose does tragic drama serve?

4. In the article, the author discusses the use of language including obscenity in drama. What does he say about the use of obscenity and attempts to censor obscenity? What does he say about the very notion of the term *obscenity*?

5. What does the author say about his own use of language and obscenity? What function do they serve in his plays?

Research Topics

1. What is naturalism? What are the criteria that define it? Read a play by the author and discuss how it does or does not fit in the category of naturalism.

2. Read a play by Howard Barker and examine its use of obscenity. Does it serve the purpose the playwright suggests it should? How is the language used?

BRECHTIAN SEXUAL POLITICS IN THE PLAYS OF HOWARD BARKER *by Desmond Gallant*

Introduction

Howard Barker is a champion of radical theatre challenging theatrical conventions and advocates for a new theatre. Desmond Gallant is a professor of theatre at Florida Atlantic University. From his early years as a theatre practitioner, Gallant has had a fascination with both the Brechtian theatrical paradigm and the contrasting paradigms of Howard Barker.

In this article, Gallant examines the use of sexuality in Barker's plays and compares and contrasts that use with that of Brecht. Barker, who in many ways objects to the Brechtian desire for absolutism, rejected much of Brecht's raison d'etre yet, despite this, has shown himself greatly influenced by Brecht and Brecht's theatre, the Epic Theatre. This article examines one such way, the depictions of human sexuality.

Bertolt Brecht's impact on the contemporary vision of theatre is widespread. This includes American feminist theatre, which has identified its development with Brechtian methodology—"Individual playwrights, feminist theatre groups, and other women who have assumed leadership roles in the contemporary theatre have linked their work with Brecht's in a variety of ways"[1]—and contemporary German playwrights such as Rainer Werner Fassbinder, whose "place in the line of haters of traditional theatre can be seen in his affinity with early Brecht,"[2] and Heiner Müller, Peter Hacks, and Helmut Baierl, who Rolf Rohmer says could be considered as "Brecht's disciples" whose "style and method of playwriting were—however individual and different—unmistakably Brechtian."[3] Brecht has shown himself to be most influential, however, with regard to British playwriting. Many British playwrights working today show at least some sign of having been swayed by the waves and ripples of Brecht's theatrical armada. Whether it be in struc-tural design, political ideology, or social philosophy, and whether it be conscious or subconscious, the effect Brecht has had is clear.

One playwright in particular is an interesting example. Howard Barker strives for a theatre that rejects much of Brecht's *raison d'être*: "[T]he audience had to share my not knowing," he writes, "when it was accustomed to being taught. . . . So the audience was sometimes angered, being used to . . . the Brechtian absolutism."[4] There can be no doubt, however, that he has been influenced by Brecht all the same.

Eric Bentley has said of Brecht, "In England he influenced playwrights, too. Was this good?. . .These things are hard to gauge. Who knows what Edward Bond would have been without Brecht? Maybe less dryly didactic and better."[5] This is hardly the point. The question to ask is not what Bond would have been without Brecht but what he is *with* Brecht. The point is not whether the influence was good or bad but that there was influence.

[1] Karen Laughlin, "Brechtian Theory and American Feminist Theatre," in *Reinterpreting Brecht: His Influence on Contemporary Drama and Film*, ed. Pia Kleber and Colin Visser (Cambridge, 1990), 147.
[2] Denis Calandra, "The Antitheater of R. W. Fassbinder," in *Plays*, by Rainer Werner Fassbinder (New York, 1985), 9.
[3] Rolf Rohmer, "Two Generations of Post-Brechtian Playwrights in the German Democratic Republic," in *Re-interpreting Brecht: His Influence on Contemporary Drama and Film*, ed. Pia Kleber and Colin Visser (Cambridge, 1990), 54.
[4] Howard Barker, "Ye Gotta Laugh," in *Arguments for a Theatre*, 2nd ed. (Manchester, 1993), 21.
[5] Eric Bentley, "The Influence of Brecht," in *Re-interpreting Brecht: His Influence on Contemporary Drama and Film*, ed. Pia Kleber and Colin Visser (Cambridge, 1990), 193–94.

A good playwright, like any other artist, can be influenced, but he then transmutes that influence into his own personal style and speaks with his own original voice. This is something that Barker has excelled at, and of particular significance is the manner in which he depicts human sexuality and how his treatment can be traced back to Brecht.

Throughout the history of art, human sexuality has been a most potent topic and theme, and this holds no less true for the theatre than for other arts. From Sophocles's *Oedipus Rex* to Ionesco's *The Lesson*, from Ibsen's *Ghosts* to Mamet's *Sexual Perversity in Chicago*, the power sexuality wields is tremendous.

Brecht understood this, and human sexuality and its perversion found a comfortable home in his work. As he developed his Marxist ideology and began to view capitalism as "synonymous with regression, corruption, and the absence of human values,"[6] he began to identify sex and money as capitalist tools of power and control. He saw how human sexuality was no longer just an expression of love and tenderness but something exploited as a means of attaining and maintaining supremacy, and he represented that observation thematically and symbolically in his plays. His theatre is rampant with a cynical view of love and sexuality. Perhaps nowhere is this expressed more overtly than in his first play, *Baal*, in which "[w]omen function only as objects for Baal's lust as they are seduced or raped or driven to suicide."[7] As for Barker, Brecht's treatment became a springboard from which he launched into an even less subtle, and perhaps more intense and poetic, use of sexuality. As Alan Thomas has put it, "Barker certainly directs himself into areas of human behaviour which challenge the power of reason—one continuing theme being the complexity of human desire."[8]

In order to establish how Brecht has influenced Barker's treatment of human sexuality, it would be wise to examine briefly how his influence exerted itself in other, more overt ways. Brecht's theatre—self-titled The Epic Theatre—was born of a belief that the traditional theatre of his time was no longer valid to its audience and that a new theatre was required, a theatre that instructed. He wanted a theatre in which the audience's intellectual abilities were actively employed and in which emotional involvement took a back seat. He believed the playwright was the instructor and the play should be the textbook.

The Epic Theatre, as Brecht developed it, exercised certain theatrical—conventions—conventions now termed *Brechtian*—whose primary function was to interrupt the flow of the narrative and disemploy the use of plot, thus disengaging the audience from an empathic response and providing them with the opportunity to question intellectually and to analyze what was being presented. These conventions included "songs, music, titles, mixing [of] different forms of writing, the literarization of the theatre, the anti-illusionistic effects" compounding a *presentational* style as opposed to a *representational* one. In England, this has "become, in many quarters . . . the established way of making theatre," and what the English did was to "assimilate in a broad way . . . the whole range of Brechtian formal categories."[9]

Towards the end of his life Brecht was again rethinking his theory of theatre and began actively to develop a new formula. "An effort is now being made," he wrote, "to move on from the epic theatre to the dialectical theatre. In our view and according to our intention the epic theatre's practice—and the whole idea—were by no means undialectical. Nor would a dialectical theatre succeed without the epic element. All the same we envisage a sizeable transformation."[10] This "sizeable transformation" was begun and further developed by many playwrights—Edward Bond ("by choosing a surrealist theatrical style to express dialectical arguments"[11]) and Caryl Churchill, to name a couple. And Howard Barker, who had started out writing epic plays, has now embarked on an even more sizeable transformation, the development of his own "Theatre of Catastrophe"—a theatre that is dedicated to the non-realistic, non-naturalistic form; a theatre that demands that the imaginative be presented; a theatre that offers no answers or

[6]Tony Calabro, *Bertolt Brecht's Art of Dissemblance* (Wakefield, NH, 1990), 53–4.

[7]Ibid., 43.

[8]Alan Thomas, "Howard Barker: Modern Allegorist," in *Modern Drama* 35:3 (1992), 434.

[9]Maro Germanou, "Brecht and the English Theatre," in *Brecht in Perspective*, ed. Graham Bartram and Anthony Waine (London, 1982), 220–21.

[10]Bertolt Brecht, "Appendices to the 'Short Organum,'" in *Brecht on Theatre*, trans, John Willett (New York, 1964), 281.

[11]Tony Coult, *The Plays of Edward Bond* (London, 1977), 56.

solutions and where the onus is put on the audience to make their own deductions individually. Barker's belief is that the theatre that wishes to instruct is the theatre that insults with its own arrogance by presuming that it is more knowledgeable than the audience. Barker says that in a new theatre it is not an insult to offer the audience ambiguity.

This new theatre bears an uncanny resemblance to the theatre that Heiner Müller developed, so much so that one is led to believe that, for both, it is born out of a conscious need to rebel against Brechtian epic theatre. Heiner Müller says: "What I try to do in my writings is to strengthen the sense of conflicts, to strengthen confrontations and contradictions. . . . I'm not interested in answers and solutions. I don't have any to offer. I'm interested in problems and conflicts."[12] And while it may seem as though Barker has disassociated himself from Brecht completely, this is not entirely the case; Barker's theatre still makes use of many Brechtian conventions, though its goal might be different. When describing his vision of a new theatre, Howard Barker advocates the use of such Brechtian methods as "breaking of the narrative thread, the sudden suspension of the story, the interruption of the obliquely related interlude, and a number of devices designed to complicate and to overwhelm the audience's habitual method of seeing."[13] It should also be noted that both of these playwrights rebelled against what they felt was a theatre rotting of stagnancy and that both were in a continuous process of writing what would eventually become their "manifestos." And it is not surprising to note that many of the articles in Barker's *Arguments for a Theatre* bear a great structural similarity to those of Brecht.

Within the body of Brecht's drama, sex is explicit and tangible while love is ephemeral and elusive. For many of Brecht's characters, the search for love and companionship is a constant preoccupation but rarely is it attained, except occasionally for a relatively brief period of time, and then usually only for some immediate physical gratification or profiteering. In the Brechtian "love story," a promise or commitment is made only so that it may be broken later on. More often than not, the broken promise is perpetrated by one of the "lovers" because the original commitment was made solely for personal gain and not out of love.

In *The Good Person of Szechwan*, Brecht's theme of love and sex for personal gain and profit is expressed in several ways, beginning with the gods' declaration that they have found a "good person" in Shen Teh, a prostitute.[14] But Shen Teh's goodness, where society is concerned, is called into question when The Policeman says: "Shen Teh, let's face it, lived by selling herself to men [. . .] it is not respectable [. . .] respectability means, not with the man who can pay, but with the man one loves" (212). Brecht then cleverly subverts the idea that marriage for love ever occurs or is even possible by sabotaging two potential marriages of love, the first of which is a marriage arranged by Shui Ta between Mr. Shu Fu and Shen Teh, a marriage that means that once again she must "prostitute" herself since she does not love him but needs the financial support. The second sabotaged marriage is that between Shen Teh and Yang Sun. Where Shen Teh falls in love, Yang Sun sees profit, thus ultimately prostituting himself and subverting love by sexual desire and profiteering.

> [YANG] SUN, *amused* [. . .] Haven't they ever told you about the power of love, the twitching of the flesh? [. . .]
>
> SHUI TA My cousin is indebted to you because. . . .
>
> [YANG] SUN Let's say because I've got my hand inside her blouse? (235)

In *Mother Courage and Her Children*, the only substantial "love" affair expressed is, again, the love of money and profit, while all other loving relationships are cynically dismissed. "Let that be a lesson, Kattrin [. . .] He says he'd like to kiss the ground your feet walk on [. . .] and after that you're his skivvy."[15] And, "Got more girls in trouble than he has fingers [. . . .] How I loved this man! All the

[12]Heiner Müller, quoted by Carl Weber, in his Introduction to *Hamletmachine and Other Texts for the Stage* (New York, 1984), 17–18.

[13]Howard Barker, "The Consolations of Catastrophe," in *Arguments for a Theatre*, 2nd ed. (Manchester, 1993), 53.

[14]Bertolt Brecht, *The Good Person of Szechwan*, in *Plays: Two*, by Bertolt Brecht, trans. John Willett, World Dramatists (London, 1987), 192. Subsequent references appear parenthetically in the text.

[15]Bertolt Brecht, *Mother Courage and Her Children*, in *Plays: Two*, 118. Subsequent references appear parenthetically in the text. The speaker here is Mother Courage. In the next quoted passage it is the prostitute, Yvette.

time he had a little dark girl with bandy legs, got her in trouble too of course [. . . .] Fancy a creature like that ever making me leave the straight and narrow path" (161–62).

In scene three, with Kattrin's donning of Yvette's boots and hat, it becomes evident that she desires her own onset of womanhood and therefore the potential for love and marriage. Unfortunately, Kattrin has been raped and disfigured by soldiers, thus destroying any hope she may have for happiness in love. And so Kattrin becomes one of the most moving symbols of unfulfilled love in Brecht's canon, when she sacrifices her hopes, dreams, and life in order to save the village.

Like Brecht's, Howard Barker's "love stories" are undermined by a complete absence of tenderness but also through brutal displays of sexuality. In his adaptation of *Women Beware Women* by Thomas Middleton, marriage is celebrated in terms of financial gain and possession, while sexual unions occur for profit, lust, and power. Leantio upon his return home introduces his new wife, Bianca, to his mother as an investment or commodity that he has stolen: "Oh, you have named the most undervalued'st purchase [. . .] as I look upon that treasure [. . .] 'tis theft [. . .]."[16]

The lust for possession and control becomes the downfall here as well, as Leantio leaves Bianca behind while he takes a business trip. They have scarcely returned when instead of nurturing his "love" for his wife, he nurtures his lust for profit. This betrayal and this lack of attention set the tone of disintegration immediately. Upon his return, he treats her like a "priceless object" which he must keep from public view lest she be stolen away— precautions taken too late, since she has already been espied by the Duke while Leantio was tending to his other affairs. Through a seduction and metaphorical, foreshadowing rape, the Duke steals her away and it is Bianca's lust for wealth that allows her to be stolen once again. In spite and desperation Leantio then takes up with Livia, and the two share an explosive and violent sexual relationship, in which Leantio expresses his fears that he "killed her [. . .] all bruises and dragged hair" (19). Both of these new relationships are again expressed in Brechtian terms of possession, ownership, and domination; however, Barker pushes them into

extremes of hate, abuse, and self-loathing. Where Brecht expresses sexual relationships in terms of the schizophrenic love/profit, Barker adds the dualities of master and slave, abuser and abused, owner and property. In a world where most are powerless, power becomes the foremost desire:

LIVIA You hurt me, and I welcome the hurt. I thought once, I am dying, and I did not mind. [. . .] All other men I thought, enough, roll off and leave my premises. The ecstasy of being left, silence and the reclamation of myself. Not you, though. [. . .]

LEANTIO [. . .] I am slave and master to you alone. Above you I struggle with a girl, beneath I submit to the hag who lurks inside [. . . .] Tell me your fuck history, you used and used again whore –

LIVIA He abuses me. . . .

LEANTIO Yes! And by abuse I praise you, lavish bitch, hunted and devoured female—(19)

It is through this desire for power that Livia engineers the rape of Bianca, which occurs on the day she is to be wedded to the Duke. Bianca is once again reduced to the role of chattel that must be not just stolen but tarnished and destroyed. She becomes the target of hate and desperation. When the Duke arrives moments after her violation, insult is added to injury, as she is once again reviled with his exclamation, "Oh, my property! [. . .] I am defiled!" (33). The scene and play conclude in a series of statements that exemplify the whole theme of lust for profit and dominance and the non-existence of love:

LIVIA [. . .] Get Christ out of your pocket. He knew money strangled love, and love's corpse stifled imagination, and dead imagination was the ground from which more money grew. Money, death, and money! [. . .]

CARDINAL [. . .] Love! To hear you speak of love who engineered this agony! **Murder of words.** [. . .]

DUKE [. . .] Don't love. . . ! Don't love. . . ! (36)

In Barker's *The Castle*, love and tenderness are shown to thrive in a female-dominated society, while they are crushed in the male-dominated so-

[16]Thomas Middleton and Howard Barker, *Women Beware Women* (New York, 1986), 1. Subsequent references appear parenthetically in the text.

ciety. Stucley, a knight, and his entourage including his servant Batter, return home after years of fighting in the Crusades. Upon their return, certain themes are immediately established, among them the equating of love, the human body, and sex with property. Standing on a hill, overlooking the homeland below, Batter rages at the apparent neglect of and disrespect for the land: "You are looking on my meadow. On my meadow which—[. . .] NO CUNT HAS MOWN! [. . .] Have you seen this! [. . .] Fallow, every fucking thing!" Stucley supports and furthers the argument:

> ALL BASTARD ROTTEN! [. . .] Ask them what they—my territory—what they—[. . . .] They have stripped me of every kind thought by this. [. . .] Oh, I am so full of good, why does everything betray me? BECAUSE IT IS THE WAY OF THE WORLD! GOOD! All tenderness is doomed to ridicule [. . .] IS MY WIFE DEAD? Must be, must be because I love her so, she's dead, it stands to reason [. . . .] What was it, fever? [. . .] No, she was banged to death by bandits. . . ."[17]

In these opening lines the progression goes from the perceived neglect, desecration, and death of the homeland territory, into blaming the women who are alluded to as territory, then into desperation that the owned woman has been desecrated. The exclamatory remark "no cunt has mown," coupled with the use of the word "fallow," suggests also that no cunt has *been* mowed either. Barker creates a duality in the implication that is based on gender perspective. From the male standpoint their absence means the "meadows" are rotting owing to the lack of plowing, whereas from the female perspective the absence of the "mowers" has meant that the fallow meadows have had an opportunity to regain their fertility. Metaphorically speaking, the land is the female body and the female body is the female society—a society which is revitalizing love and human tenderness. The return of the males means a return to death and destruction, to a society dry of love where meadow and cunt shall be mown and fucking shall be fertility once again. The metaphor of these polarities is furthered when, still in the first scene, Ann, Stucley's wife, says, "A woman, this country, not arid like your place"

(5). These two polar expressions of love are made even clearer when Skinner, who has been sharing a lesbian relationship with Ann, says,

> First there was the bailiff, and we broke the bailiff. And then there was God, and we broke God. And lastly there was cock, and we broke that, too. Freed the ground, freed religion, freed the body [. . .] and FOUND CUNT BEAUTIFUL that we had hidden and suffered shame for, its lovely shapelessness, its colour all miraculous, what they had made dirty or worshipped out of ignorance [. . . .] And [I] washed you, and parted your hair. I never knew such intimacy, did you? (6–7)

On the one hand, this expression of love arises out of a freeing of sexuality and an embracement of tenderness; while on the other hand, the male societal expression of love is revealed in an exchange between Ann and Stucley:

> ANN You've not changed. . . . Whereas quietly, here I have.
>
> STUCLEY [. . .]. Fuck the garment! Get to bed with me and we'll stir up long forgotten feelings. . . .
>
> ANN It isn't possible –
>
> STUCLEY IT IS, YOU LIE DOWN AND YOU PART YOURSELF. (8)

A new and more humane society with love, tenderness, and justice had evolved. The return of the men was and is not welcome and yet it does stir some now unfamiliar desires inherent in Ann. Those desires overpower her and she once again accepts the male society and has an affair with Krak, an engineer whom Stucley brought to design his new castle. Skinner alone fights off the invasion and is eventually punished for murder—a punishment that is extremely brutal and gruesome. The male society re-establishes and reclaims religion, family, and justice, all of which become fused with brutality and sexuality. The maleness of the society destroys love and tenderness.

On a purely clinical level, human sexuality functions primarily as a means of propagating the species. In the theatre of Brecht, the conception of a child is usually treated as a haphazard by-product of the sexual act. And while the child as a symbol of hope is prevalent in Brecht's work, his

[17]Howard Barker, *The Castle: A Triumph*, in *The Castle, Scenes from an Execution* (New York, 1985), 3–4. Subsequent references appear parenthetically in the text.

characters rarely conceive out of hope or love but rather with little thought or regard for the consequences. Brecht's "children" usually embody innocence, purity, selflessness, and dependence and are held up as paradigms of human moral potential.

Grusha, in *The Caucasian Chalk Circle*, does everything she can within her power to protect and provide for her "adopted" child, a child abandoned by its original mother and almost abandoned by Grusha. Both of these abandonments occur when the "mothers," out of fear, become selfish and lose hope. Grusha, however, through her re-embracement of the child, demonstrates her refusal to abandon hope. In the end, it is Grusha's love, faith, and dedication that lead Azdak to assign her custody of the child. In the epilogue, the singer says that children are to be given "to the maternal, that they thrive." And Grusha had already said to Simon, her fiancé, that she took the child "because on that Easter Sunday I got engaged to you. And so it is a child of love."[18]

The optimism and security of this end are not presented with such definitiveness elsewhere in Brecht. In *The Good Person of Szechwan*, for example, though Shen Teh in scene seven does express enthusiasm and optimism about her pregnancy, exclaiming, "Oh joy! A small being is coming to life in my body" (25), the end of the play is much more desperate and ambiguous:

> SHEN TEH Oh, do not go away, Illustrious Ones! [. . .] I need you terribly! [. . .] Help! [. . .]
>
> *As Shen Teh stretches desperately towards them they disappear* [. . . .] (290)

With this end, the future of Shen Teh, and consequently that of hope personified in her unborn child, are left uncertain. As the player explains in the end, hope lies in the hands of the spectator.

The concrete optimism of *Caucasian* is also lacking in *Mother Courage*, in which Kattrin is Brecht's eldest "child symbol of hope." Her final scene comprises an act of pure selflessness and serves as an example of humanity's potential. As she bangs away on the drum, she not only serves to wake up the town and save it from disaster (177–80), but is also there to wake up the audience so that we too may "save" ourselves and our society. Her destruction by the soldiers sends out a powerful warning, that if we are not careful all possibility of hope may be lost. Her success at awakening the village reminds us that, although she is killed, hope is not lost—yet.

Barker also uses children as symbols of hope and human potential, though in his case the usage is somewhat more ambivalent and perhaps even more pessimistic. Barker's use is also much more limited but he does repeatedly refer to the womb and allude to metaphorical births. *Kiss My Hands*, a short play from *The Possibilities*, is one of the few Barker instances where a child does appear in which a mother "whose intention is to prevent the world [from] inflicting any further damage on [her child's] innocence"[19] attempts to end his life. At the last moment, however, she ceases the action and allows her child to live. This stayed infanticide becomes a declaration of hope as she decides, "I will open the door . . . **I will open the door . . . !**"[20] and risk his potential damage. It is through this risk that she displays faith in the possibility that he won't be corrupted by society and that his potential may come to full fruition undefiled. True to his own playwriting and theatrical theories, Barker does not shy away from contradictions. The "infant" and "birth" in *Women Beware Women* seem to be the complete antithetical response to the optimistic faith held forth in *Kiss My Hands*. The "infant" is Bianca's rape and the "birth" is Livia's hatching of the idea: "LEANTIO So, this is the infant of our exceptional love. . . . You labour for a child as hideous as this. . . ."(31)

This "birth" however, as unpalatable and misogynistic as it may seem, is shown as an enlightening experience. This is so because in Barker's plays, extreme suffering and pain, true to the tragic form, produce cathartic recognitions in which the characters shed their old skin and emerge renewed and revitalized. In Bianca's case this new person emerges with a new sense of herself and her true worth, and with a new awareness of her

[18]Bertolt Brecht, *The Caucasian Chalk Circle*, trans. James and Tanie Stem with W.H. Auden, in *Plays: Three*, by Bertolt Brecht, World Dramatists (London, 1987), 312–13.

[19]Howard Barker, "Beauty and Terror in the Theatre of Catastrophe," in *Arguments for a Theatre*, 2nd ed. (Manchester, 1993), 58.

[20]Howard Barker, *Kiss My Hands*, in *The Possibilities* (New York, 1987), 16.

past role as object and commodity. So, although the rape is referred to as a child, it also produces a "child" of enlightenment and rediscovered faith. Bianca's renewed awareness, though still acute with pain and anger, causes her actually to thank Livia, who caused her suffering.

LEANTIO **Stay by her.** [. . .] Must. . . .

BIANCA I do not want it, Leantio. Little spasm of male pity. Male violence, male pity. The blow. The charity. Get off. . . .! [. . . .]

[. . . .]

Suddenly BIANCA *strikes* LIVIA *in the face* [. . . .]

BIANCA Thank you. . . . *They stare at one another* [. . . .] (36)

This end to the play leaves one unsure as to whether or not Bianca's re-emergence is wholly positive—an ambiguity that is unquestionably intentional on Barker's part.

In the plays of Brecht and Barker, human dignity is constantly tried and challenged. It is never easily achieved, and, once achieved, it becomes almost impossible to maintain. Faith, love and tenderness, equality and justice are constantly being undermined through extreme and insurmountable suffering. The body as a private entity rarely exists: it almost always becomes public property for corruption, debasement, humiliation, and degradation. It is beaten, tortured, ridiculed, and desecrated. Its sexual components are particularly susceptible to mistreatment, as they represent what is most intimate and personal and therefore are most powerfully exploited. The body becomes the representation of the human spirit and emotional center: to violate the body is to destroy the person. It is no wonder then that rape, prostitution as a profession and as an act of desperation, infanticide, and the mutilation of the genitalia find themselves featured so prominently in the work of these two playwrights. Brecht, in an attempt to avoid the emotional involvement of the spectator, alludes and refers, while Barker boldly and graphically displays these acts of brutal spoliation, in an effort to disturb the audience and create catharsis for all participants who share in the work of art onstage. Brecht's theatre is dialectical in purpose, alienating in methodology, with the ideal of bettering the human condition whose suffering is represented in the discomfiture of debased love and violated sexuality. Barker is more extreme. He reiterates Brecht's representation of debased love, violated sexuality, and politics of desire but discards the dialectical purpose and "alienation" methodology while embracing Bond's "aggro-effect," which "reflects a more physiological grounding . . . suggest[ing] both aggressivity and aggregation; both connotations point to a physical discomfort . . . rooted in . . . suffering."[21] and forcing it to the brink of human tolerance. Barker, through Middleton, refers to himself as "an irresponsible optimist," in his "Conversation with a Dead Poet,"[22] and while Brecht probably wouldn't say he is irresponsibly optimistic, one can safely speculate that he would have admitted to being optimistic. Although optimism is more readily discernible in Brecht's work, both do express a faith in the possibility of a better human condition. Alan Thomas says of Barker and Brecht that "both writers should be placed on the same side, as anti-realists, of the divide that has shaped much of the history of modem drama."[23] Brecht was a confirmed leftist political writer of the Marxist-socialist vein, and Barker admits as much:

I needed to know what meaning socialism had for me. . . .I found it possible to begin the play without socialism but to find socialism within the play.[24]

There is no doubt that Brecht has had a profound influence in the theatre. Many playwrights, political and non-political alike, have borrowed Brechtian techniques and themes, and Howard Barker is no exception.

[21]Stanton B. Garner, Jr., "Post-Brechtian Anatomies: Weiss, Bond, and the Politics of Embodiment," in *Theatre Journal* 42:2 (1990), 161.

[22]Howard Barker, "Conversation with a Dead Poet," in *Arguments for a Theatre*, 2nd ed. (Manchester, 1993), 25.

[23]Thomas, 441. See note 8.

[24]Barker, "Ye Gotta Laugh," 21. See note 4.

BRECHTIAN SEXUAL POLITICS IN THE PLAYS OF HOWARD
BARKER *by Desmond Gallant*

Discussion Questions

1. Early in the article, the author, Desmond Gallant, begins by describing the methodology and *raison d'etre* of Brecht's Epic Theatre. He suggests that by "interrupt[ing] the flow of the narrative and disemploy[ing] the use of plot," the Epic Theatre hopes to have what effect on the audience?

2. The author suggests that playwright Howard Barker feels that "in a new theatre it is not an insult to offer the audience –" What? And what does Barker mean by this?

3. What *Brechtian* methods does Barker advocate using?

4. Gallant argues that Barker's "love stories" resemble Brecht's in that they are undermined in what two ways?

5. Through the use of the metaphor of "mowing" the author suggests that there is a dichotomy in how that metaphor is perceived based on gender perspective. What is that dichotomy or duality? What is the difference in perspective of the two genders?

6. The author demonstrates that Bianca's rape in *Women Beware Women* is shown as an "enlightening experience." According to the author, in what ways is this in keeping with the tragic form?

7. What does the author argue it is about the body's sexual parts that make them particularly susceptible to mistreatment? And what is the ultimate outcome that arises from the violation of the sexual body?

8. The author states that Brecht "alludes and refers" in an attempt to avoid the emotional involvement of the spectator and then suggests Barker approaches his work in a different way. What is that difference and what does the author suggest is the reason for that difference?

Research Topics

1. Read both the original *Women Beware Women* by Thomas Middleton and the Howard Barker adaptation and then compare and contrast the depictions of sexuality in each.

2. Read Howard Barker's treatise *Arguments for a Theatre*. Pick the five or so articles you feel are most important in imparting Barker's theories of theatre? What do they address and why are they are the most important?

THE GROUND ON WHICH I STAND *by August Wilson*

Introduction

In June 1996, at the Theatre Communication Group's eleventh biennial conference, playwright August Wilson stood up before a large crowd of theatre artists and delivered a passionate keynote address. That address, titled "The Ground on Which I Stand," managed to offend many, energize many others, and refocus the agenda of the entire conference. August Wilson is one of America's foremost playwrights. His plays, all of which dramatize the struggles and celebrations of African–Americans and their individual histories, are powerful, engaging, and provocative.

"The Ground on Which I Stand" challenges the structures, practices, and conventions of the American not-for-profit theatre landscape. It raises questions of racism, classism, African–American social history, and some of the most cherished policies of the liberal theatre establishment, including the notion of "colorblind casting."

Within the words of this address can be heard a passionate (sometimes loving, sometimes angry) voice screaming for African–Americans to seize control of their own destinies, for the America-of-the-People to stand by and serve all of its people, and for the established "white" theatre to cease its derogatory and demeaning practices. He demands that the American theatre recognize that its modus operandi is one of denial and subjugation of the minority while perpetuating a self-sustaining structure that serves the majority. In this argument, he addresses questions of arts funding and ticket pricing, and how they are designed to serve the social majority.

This address sparked months of fierce debate about cultural diversity in the American theatre—many questions of which remain unanswered to this day.

Some time ago I had an occasion to speak to a group of international playwrights. They had come from all over the world—from Colombia, Chile, from New Guinea, Poland, China, Nigeria, Italy, France, Great Britain. I began my remarks by welcoming them to my country. I didn't always think of it as my country, but since my ancestors have been here since the early seventeenth century, I thought it as good a beginning as any. So I say if there are any foreigners here in the audience, welcome to my country.

I wish to make it clear from the outset that I do not have a mandate to speak for anyone. There are many intelligent blacks working in the American theatre who speak in a loud and articulate voice. It would be the greatest of presumptions to say that I speak for them. I speak only for myself and those who may think as I do.

I have come here today to make a testimony, to talk about the ground on which I stand and all the many grounds on which I and my ancestors have toiled, and the ground of theatre on which my fellow artists and I have labored to bring forth its fruits, its daring and its sometimes lacerating, and often healing, truths.

The first and most obvious ground I am standing on is this platform, that I have so graciously been given at the 11th biennial conference of the Theatre Communications Group. It is the Theatre Communications Group to which we owe much of our organization and communication, and I am grateful to them for entrusting me with the grave responsibility of sounding this keynote, and it is my hope to discharge my duties faithfully. I first attended the conference in 1984, and I recall John Hirsch's eloquent address on the "Other" and I mark it as a moment of enlightenment and import. And I am proud and thankful to stand here tonight in my embrace of that moment and to find myself on this platform. It is a moment I count well and mark with privilege.

In one guise, the ground I stand on has been pioneered by the Greek dramatists—by Euripides, Aeschylus and Sophocles—by William

Shakespeare, by Shaw, Ibsen and Chekov, Eugene O'Neill, Arthur Miller, Tennessee Williams. In another guise, the ground that I stand on has been pioneered by my grandfather, by Nat Turner, by Denmark Vesey, by Martin Delaney, Marcus Garvey and the Honorable Elijah Muhammad. That is the ground of the affirmation of the value of one's being, an affirmation of his worth in the face of this society's urgent and sometimes profound denial. It was this ground as a young man coming into manhood searching for something to dedicate my life to that I discovered the Black Power Movement of the '60s. I felt it a duty and an honor to participate in that historic moment. As a people who had arrived in America chained and malnourished in the hold of a 350-foot Portuguese, Dutch or English sailing ship, we were now seeking ways to alter our relationship to the society in which we live—and, perhaps more important, searching for ways to alter the shared expectations of ourselves as a community of people.

I find it curious but no small accident that I seldom hear those words "Black Power" spoken, and when mention is made of that part of black history in America, whether in the press or in conversation, reference is made to the Civil Rights Movement as though the Black Power Movement—an important social movement by America's exslaves—had in fact never happened. But the Black Power Movement of the '60s was [in fact] a reality; it was the kiln in which I was fired, and has much to do with the person I am today and the ideas and attitudes that I carry as part of my consciousness.

I mention this because it is difficult to disassociate my concerns with theatre from the concerns of my life as a black man, and it is difficult to disassociate one part of my life from another. I have strived to live it all seamless—art and life together, inseparable and indistinguishable. The ideas I discovered and embraced in my youth when my idealism was full blown I have not abandoned in middle age when idealism is something less than blooming, but wisdom is starting to bud. The ideas of self-determination, self-respect and self-defense that governed my life in the '60s I find just as valid and self-urging in 1996. The need to alter our relationship to the society and to alter the shared expectations of ourselves as a racial group I find of greater urgency now than it was then.

I am what is known, at least among the followers and supporters of the ideas of Marcus Garvey, as a "race man." That is simply that I believe that race matters—that is the largest, most identifiable and most important part of our personality. It is the largest category of identification because it is the one that most influences your perception of yourself, and it is the one to which others in the world of men most respond. Race is also an important part of the American landscape, as America is made up of an amalgamation of races from all parts of the globe. Race is also the product of a shared gene pool that allows for group identification, and it is an organizing principle around which cultures are formed. When I say culture I am speaking about the behavior patterns, the arts, beliefs, institutions and all other products of human work and thought as expressed by a particular community of people.

There are some people who will say that black Americans do not have a culture—that cultures are reserved for other people, most notably Europeans of various ethnic groupings, and that black Americans make up a sub-group of American culture that is derived from the European origins of its majority population. But black Americans are Africans, and there are many histories and many cultures on the African continent.

Those who would deny black Americans their culture would also deny them their history and the inherent values that are a part of all human life.

Growing up in my mother's house at 1727 Bedford Avenue in Pittsburgh, PA, I learned the language, the eating habits, the religious beliefs, the gestures, the notions of common sense, attitudes towards sex, concepts of beauty and justice, and the responses to pleasure and pain. . . that my mother had learned from her mother, and which you could trace back to the first African who set foot on the continent. It is this culture that stands today on these shores today as a testament to the resiliency of the African-American spirit.

The term black or African-American not only denotes race, it denotes condition, and carries with it the vestige of slavery and the social segregation and abuse of opportunity so vivid in our memory. That this abuse of opportunity and truncation of possibility is continuing and is so pervasive in our society in 1996 says much about who we are and much about the work that is necessary to alter our perceptions of each other and to effect meaningful prosperity for all.

The problematic nature of the relationship between whites and blacks has for too long led us astray from the fulfillment of our possibilities as a society. We stare at each other across a divide of economics and privilege that has become an encumbrance on black Americans' ability to prosper and on the collective will and spirit of our national purpose.

I speak about economics and privilege, one significant fact affects us all in the American theatre: of the sixty-six LORT theatres, there is one that can be considered black. From this it could be falsely assumed that there aren't sufficient numbers of blacks working in the American theatre to sustain and support more theatres.

If you do not know, I will tell you: black theatre in America is alive, it is vibrant, it is vital . . . it just isn't funded.

Black theatre doesn't share in the economics that would allow it to support its artists and supply them with meaningful avenues to develop their talent and broadcast and disseminate ideas crucial to its growth. The economics are reserved as privilege to the overwhelming abundance of institutions that preserve, promote and perpetuate white culture.

That is not a complaint. That is an advertisement. Since the funding sources, both public and private, do not publicly carry avowed missions of exclusion and segregated support, this is obviously either a glaring case of oversight, or we the proponents of black theatre have not made our presence or our needs known. I hope here tonight to correct both of those oversights and assumptions.

I do not have the time in this short talk to reiterate the long and distinguished history of black theatre—often accomplished amid adverse and hostile conditions—but I would like to take the time to mark a few high points.

There are and have always been two distinct and parallel traditions in black art: that is, art that is conceived and designed to entertain white society, and art that feeds the spirit and celebrates the life of black America by designing its strategies for survival and prosperity.

An important part of black theatre that is often ignored but is seminal to its tradition is its origins on the slave plantations of the South. Summoned to the "big house" to entertain the slave owner and his guests, the slave began a tradition of theatre as entertainment for whites that reached its pinnacle in the heyday of the Harlem Renaissance. This entertainment for whites consisted of whatever the slave imagined or knew that his master wanted to see and hear. This tradition has its present-life counterpart in the crossover artists that slant their material for white consumption.

The second tradition occurred when the African in the confines of the slave quarters sought to invest his spirit with the strength of his ancestors by conceiving in his art, in his song and dance, a world in which he was the spiritual center, and his existence was a manifest act of the creator from whom life flowed. He could then create art that was functional and furnished him with a spiritual temperament necessary for his survival as property and the dehumanizing status that was attendant to that.

I stand myself and my art squarely on the self-defining ground of the slave quarters, and find the ground to be hallowed and made fertile by the blood and bones of the men and women who can be described as warriors on the cultural battlefield that affirmed their self-worth. As there is no idea that cannot be contained by black life, these men and women found themselves to be sufficient and secure in their art and their instructions.

It was this high ground of self-determination that the black playwrights of the '60s marked out for themselves. Ron Milner; Ed Bullins; Philip Hayes Dean; Richard Wesley; Lonne Elder, III; Sonia Sanchez; Barbara Ann Teer and Amiri Baraka were among those playwrights who were particularly vocal and whose talents confirmed their presence in the society, and altered the American theatre, its meaning, its craft and its history. This brilliant explosion of black arts and letters in the '60s remains for me the hallmark and the signpost that points the way to our contemporary work on the same ground. Black playwrights everywhere remain indebted to them for their brave and courageous forays into an area that is marked with land mines and the shadows of snipers—those who would reserve the territory of arts and letters and the American theatre as their own special province and point blacks toward the ball fields and the bandstands.

That black theatre today comes under such assaults should surprise no one, as we are on the verge of reclaiming and reexamining the purpose and pillars of our art and laying out new directions for its expansion. And as such we make a target for cultural imperialists who seek to empower and propagate their ideas about the world as the only valid ideas, and see blacks as woefully deficient not only in arts and letters but in the abundant gifts of humanity.

In the nineteenth century, the lack of education, the lack of contact with different cultures, the expensive and slow methods of travel and communication fostered such ideas, and the breeding ground of ignorance and racial intolerance promoted them.

The King's English and the lexicon of a people given to such ignorance and intolerance did not do much to dispel such obvious misconceptions, but provided them with a home. I cite *Webster's Third New International Dictionary*:

> "BLACK: outrageously wicked, dishonorable, connected with the devil, menacing, sullen, hostile, unqualified, illicit, illegal, violators of public regulations, affected by some undesirable condition. . ." etc.

> "WHITE: free from blemish, moral stain or impurity; outstandingly righteous, innocent; not marked by malignant influence; notably auspicious, fortunate, decent; a sterling man."

Such is the linguistic environment that informs the distance that separates blacks and whites in America and which the cultural imperialists, who cannot imagine a life existing and flourishing outside their benevolent control, embraces.

Robert Brustein, writing in an article/review titled "Unity from Diversity" [*The New Republic*, July 19–26, 1993], is apparently disturbed that "there is a tremendous outpouring of work by minority artists" which he attributes to cultural diversity. He writes that the practice of extending invitations to a national banquet from which a lot of hungry people have long been excluded is a practice that can lead to confused standards. He goes on to establish a presumption of inferiority of the work of minority artists: "Funding agencies have started substituting sociological criteria for aesthetic criteria in their grant procedures, indicating that 'elitist' notions like quality and excellence are no longer functional." He goes on to say: "It's disarming in all senses of the word to say that we don't share common experiences that are measurable by common standards. But the growing number of truly talented artists with more universal interests suggests that we may soon be in a position to return to a single value system."

Brustein's surprisingly sophomoric assumption that this tremendous outpouring of work by minority artists leads to confusing standards and that funding agencies have started substituting sociological for aesthetic criteria, leaving aside notions like quality and excellence, shows him to be a victim of nineteenth-century thinking and the linguistic environment that posits blacks as unqualified. Quite possibly this tremendous outpouring of works by minority artists may lead to a *raising* of standards and a *raising* of the levels of excellence, but Mr. Brustein cannot allow that possibility.

To suggest that funding agencies are rewarding inferior work by pursuing sociological criteria only serves to call into question the tremendous outpouring of plays by white playwrights who benefit from funding given to the sixty-six LORT theatres.

Are those theatres funded on sociological or aesthetic criteria? Do we have sixty-six excellent theatres? Or do those theatres benefit from the sociological advantage that they are run by whites and cater to largely white audiences?

The truth is that often where there are aesthetic criteria of excellence, it is the sociological criteria that have traditionally excluded blacks. I say raise the standards and remove the sociological conditions of race as privilege, and we will meet you at the cross-roads, in equal numbers, prepared to do the work of extending and developing the common ground of the American theatre.

We are capable of work of the highest order; we can answer to the high standards of world-class art. And anyone who doubts our capabilities at this late stage is being intellectually dishonest.

We can meet on the common ground of theatre as a field of work and endeavor. But we cannot meet on the common ground of experience.

Where is the common ground in the horrifics of lynching? Where is the common ground in the maim of the policeman's bullet? Where is the common ground in the hull of a slave ship or the deck of a slave ship with its refreshments of air and expanse?

We will not be denied our history.

We have voice and we have temper. We are too far along this road from the loss of our political will, we are too far along the road of reassembling ourselves, too far along the road to regaining spiritual health to allow such transgression of our history to go unchallenged.

The commonalties that we share are the commonalities of culture. We decorate our houses. That is something we do in common. We do it differently because we value different things. We have different manners and different values of social intercourse. We have different ideas of what a party is.

There are some commonalities to our different ideas. We both offer food and drink to our guests,

but because we have different culinary values, different culinary histories, we offer different food and drink to our guests. As an example, in our culinary history, we have learned to make do with the feet and ears and tails and intestines of the pig rather than the loin and the ham and the bacon. Because of our different histories with the same animal, we have different culinary ideas. But we share a common experience with the pig as opposed to say Muslims and Jews, who do not share that experience.

We can meet on the common ground of the American theatre.

We cannot share a single value system if that value system consists of the values of white Americans based on their European ancestors. We reject that as Cultural Imperialism. We need a value system that includes our contributions as Africans in America. Our agendas are as valid as yours. We may disagree, we may forever be on opposite sides of aesthetics, but we can only share a value system that is inclusive of all Americans and recognizes their unique and valuable contributions.

The ground together: We must develop the ground together. We reject the idea of equality among equals, but we say rather the equality of all men.

The common values of the American theatre that we can share are plot . . . dialogue . . . characterization . . . design. How we both make use of them will be determined by who we are and what ground we are standing on and what our cultural values are.

Theatre is part of art history in terms of its craft and dramaturgy, but it is part of social history in terms of how it is financed and governed. By making money available to theatres willing to support colorblind casting, the financiers and governors have signaled not only their unwillingness to support black theatre but their willingness to fund dangerous and divisive assaults against it. Colorblind casting is an aberrant idea that has never had any validity other than as a tool of the Cultural Imperialists who view their American culture, rooted in the icons of European culture, as beyond reproach in its perfection. It is inconceivable to them that life could be lived and enriched without knowing Shakespeare or Mozart. Their gods, their manners, their being, are the only true and correct representations of humankind. They refuse to recognize black conduct and manners as part of a system that is fueled by its own philosophy, mythology, history, creative motif, social organization and ethos. The idea that blacks have their own way of responding to the world, their own values, style, linguistics, their own religion and aesthetics, is unacceptable to them.

For a black actor to stand on the stage as part of a social milieu that has denied him his gods, his culture, his humanity, his mores, his ideas of himself and the world he lives in, is to be in league with a thousand naysayers who wish to corrupt the vigor and spirit of his heart.

To cast us in the role of mimics is to deny us our own competence.

Our manners, our style, our approach to language, our gestures, and our bodies are not for rent. The history of our bodies—the maimings, the lashings, the lynchings, the body that is capable of inspiring profound rage and pungent cruelty—is not for rent. Nor is the meaning of our history or our bodies for rent.

To mount an all-black production of *Death of a Salesman* or any other play conceived for white actors as an investigation of the human condition through the specifics of white culture is to deny us our own humanity, our own history, and the need to make our own investigations from the cultural ground on which we stand as black Americans. It is an assault on our presence, and our difficult but honorable history in America; and it is an insult to our intelligence, our playwrights, and our many and varied contributions to the society and the world at large.

The idea of colorblind casting is the same idea of assimilation that black Americans have been rejecting for the past 380 years. For the record, we reject it again. We reject any attempt to blot us out, to reinvent our history and ignore our presence or to maim our spiritual product. We must not continue to meet on this path. We will not deny our history, and we will not allow it to be made to be of little consequence, to be ignored or misinterpreted.

In an effort to spare us the burden of being "affected by an undesirable condition" and as a gesture of benevolence, many whites (like the proponents of colorblind casting) say, "Oh, I don't see color." We want you to see us. We are black and beautiful. We are not patrons of the linguistic environment that would have us as "unqualified," and "violators of public regulations." We are not ashamed. We have an honorable history in the world of men. We come from a long line of honorable people with complex codes of ethics

and social discourse, who devised myths and systems of cosmology and systems of economics, and who were themselves part of a long social and political history. We are not ashamed, and we do not need you to be ashamed for us. Nor do we need the recognition of our blackness to be couched in abstract phases like "artist of color." Who are you talking about? A Japanese artist? An Eskimo? A Filipino? A Mexican? A Cambodian? A Nigerian? Are we to suppose that one white person balances out the rest of humanity lumped together as nondescript "people of color"? We reject that. We are unique, and we are specific.

We do not need colorblind casting; we need theatres. We need theatres to develop our playwrights. We need those misguided financial resources to be put to better use. Without theatres we cannot develop our talents. If we cannot develop our talents, then everyone suffers: our writers, the theatre, the audience. Actors are deprived of material, and our communities are deprived of the jobs in support of the art—the company manager, the press coordinator, the electricians, the carpenters, the concessionaires, the people that work in wardrobe, the box-office staff, the ushers and the janitors. We need some theatres. We have only one life to develop our talent, to fulfill our potential as artists. One life, and it is short, and the lack of the means to develop our talent is an encumbrance on that life.

We did not sit on the sidelines while the immigrants of Europe, through hard work, skill, cunning, guile and opportunity, built America into an industrial giant of the twentieth century. It was our labor that provided the capital. It was our labor in the shipyards and the stockyards and the coal mines and the steel mills. Our labor built the roads and the railroads. And when America was challenged, we strode on the battlefield, our boots strapped on and our blood left to soak into the soil of places whose names we could not pronounce, against an enemy whose only crime was ideology. We left our blood in France and Korea and the Philippines and Vietnam, and our only reward has been the deprivation of possibility and the denial of our moral personality.

It cannot continue. The ground together: The American ground on which I stand and which my ancestors purchased with their perseverance, with their survival, with their manners and with their faith.

It cannot continue, as well as other assaults upon our presence and our history cannot continue: When the *New York Times* publishes an article on pop singer Michael Bolton and lists as his influences four white singers, and then as an afterthought tosses in the phrase "and the great black rhythm and blues singers," it cannot be anything but purposeful with intent to maim. These great black rhythm and blues singers are reduced to an afterthought on the verge of oblivion—one stroke of the editor's pen and the history of American music is revised, and Otis Redding, Jerry Butler and Rufus Thomas are consigned to the dustbin of history while Joe Cocker, Mick Jagger and Rod Stewart are elevated to the status of the originators and creators of a vital art that is a product of our spiritual travails; and the history of music becomes a fabrication, a blatant forgery which under the hallowed auspices of the *New York Times* is presented as the genuine article.

We cannot accept these assaults. We must defend and protect our spiritual fruits. To ignore these assaults would make us derelict in our duties. We cannot accept them. Our political capital will not permit them.

So much of what makes this country rich in art and all manners of spiritual life is the contributions that we as African Americans have made. We cannot allow others to have authority over our cultural and spiritual products. We reject, without reservation, any attempt by anyone to rewrite our history so as to deny us the rewards of our spiritual labors, and to become the cultural custodians of our art, our literature and our lives. To give expression to the spirit that has been shaped and fashioned by our history is of necessity to give voice and vent to the history itself.

It must remain for us a history of triumph.

The time has come for black playwrights to confer with one another, to come together to meet each other face to face, to address questions of aesthetics and ways to defend ourselves from the naysayers who would trumpet our talents as insufficient to warrant the same manner of investigation and exploration as the majority. We need to develop guidelines for the protection of our cultural property, our contributions and the influence they accrue. It is time we took the responsibility for our talents in our own hands. We cannot depend on others. We cannot depend on the directors, the managers or the actors to do the work we should be doing for ourselves. It is our

lives, our talent and the pursuit of our fulfillment that are being encumbered by false ideas and perceptions of ourselves.

It is time to embrace the political dictates of our history and answer the challenge to our duties. And I further think we should confer in a city in our ancestral homeland in the southern part of the United States in 1998, so that we may enter the millennium united and prepared for a long future of prosperity.

From the hull of a ship to self-determining, self-respecting people. That is the journey we are making.

We are robust in spirit, we are bright with laughter, and we are bold in imagination. Our blood is soaked into the soil and our bones lie scattered the whole way across the Atlantic Ocean, as Hansel's crumbs, to mark our way back home.

We are no longer in the House of Bondage, and soon we will no longer be victims of the counting houses who hold from us ways to develop and support our talents and our expressions of life and its varied meanings. Assaults upon the body politic that demean and ridicule and depress the value and worth of our existence, that seek to render it immobile and to extinguish the flame of freedom lit eons ago by our ancestors upon another continent, must be met with a fierce and uncompromising defense.

If you are willing to accept it, it is your duty to affirm and urge that defense, and that respect and that determination.

And I must mention here, with all due respect to W.E.B. DuBois, that the concept of a "talented tenth" creates an artificial superiority. It is a fallacy and a dangerous idea that only serves to divide us further. I am not willing to throw away as untalented ninety percent of my blood; I am not willing to dismiss the sons and daughters of those people who gave more than lip service to the will to live and made it a duty to prosper in spirit, if not in provision. All God's children got talent. It is a dangerous idea to set one part of the populace above and aside from the other. We do a grave disservice to ourselves not to seek out and embrace and enable all of our human resources as a people. All blacks in America, with very few exceptions—*with very few exceptions*—no matter what our status, no matter the size of our bank accounts, no matter how many and what kind of academic degrees we can place beside our names, no matter the furnishings and square footage of our homes, the length of our closets and the quality of the wool and cotton that hangs there—we all in America originated from the same place: the slave plantations of the South. We all share a common past, and despite how some of us might think and how it might look, we all share a common present and will share a common future.

We can make a difference. Artists, playwrights, actors—we can be the spearhead of a movement to reignite and reunite our people's positive energy for a political and social change that is reflective of our spiritual truths rather than economic fallacies. Our talents, our truths, our belief in ourselves is all in our hands. What we make of it will emerge from the self as a baptismal spray that names and defines. What we do now becomes history by which our grandchildren will judge us.

We are not off on a tangent. The foundation of the American theatre is the foundation of European theatre that begins with the great Greek dramatists; it is based on the proscenium stage and the poetics of Aristotle. This is the theatre that we have chosen to work in. And we embrace the values of that theatre but reserve the right to amend, to explore, and to add our African consciousness and our African aesthetic to the art we produce.

To pursue our cultural expression does not separate us. We are not separatists, as Mr. Brustein asserts. We are Americans trying to fulfill our talents. We are not the servants at the party. We are not apprentices in the kitchens. We are not the stable boys to the king's huntsmen. We are Africans. We are Americans. The irreversible sweep of history has decreed that. We are artists who seek to develop our talents and give expression to our personalities. We bring advantage to the common ground that is the American theatre.

All theatres depend on an audience for a dialogue. To the American theatre, subscription audiences are its life blood. But the subscription audience holds theatres hostage to the mediocrity of its tastes, and impedes the further development of an audience for the work that we do. While intentional or not, it serves to keep blacks out of the theatre. A subscription audience becomes not a support system but makes the patrons members of a club to which the theatre serves as a clubhouse. It is an irony that the people who can most afford a full-price ticket get discounts for subscribing, while the single-ticket buyer who cannot afford a subscription is charged the additional burden of support to offset the subscription-buyer's

discount. It is a system that is in need of overhaul to provide not only a more equitable access to tickets but access to influence as well.

I look for and challenge students of arts management to be bold in their exploration of new systems of funding theatres, including profit-making institutions and ventures, and I challenge black artists and audiences to scale the walls erected by theatre subscriptions to gain access to this vital area of spiritual enlightenment and enrichment that is the theatre.

All theatergoers have opinions about the work they witness. Critics have an informed opinion. Sometimes it may be necessary for them to gather more information to become more informed. As playwrights grow and develop, as the theatre changes, the critic has an important responsibility to guide and encourage that growth. However, in the discharge of their duties, it may be necessary for them to also grow and develop. A stagnant body of critics, operating from the critical criteria of forty years ago, makes for a stagnant theatre without the fresh and abiding influence of contemporary ideas. It is the critics who should be in the forefront of developing new tools for analysis necessary to understand new influences.

The critic who can recognize a German neo-romantic influence should also be able to recognize an American influence from blues or black church rituals, or any other contemporary American influence.

The true critic does not sit in judgment. Rather he seeks to inform his reader, instead of adopting a posture of self-conscious importance in which he sees himself a judge and final arbiter of a work's importance or value.

We stand on the verge of an explosion of playwriting talent that will challenge our critics. As American playwrights absorb the influence of television and use new avenues of approach to the practice of their craft, they will grow to be wildly inventive and imaginative in creating dramas that will guide and influence contemporary life for years to come.

Theatre can do that. It can disseminate ideas, it can educate even the miseducated, because it is art—and all art reaches across that divide that makes order out of chaos, and embraces the truth that overwhelms with its presence, and connects man to something larger than himself and his imagination.

Theatre asserts that all of human life is universal. Love, Honor, Duty, Betrayal belong and pertain to every culture and every race. The way they are acted out on the playing field may be different, but betrayal is betrayal whether you are a South Sea Islander, a Mississippi farmer or an English baron. All of human life is universal, and it is theatre that illuminates and confers upon the universal the ability to speak for all men.

The ground together: We have to do it together. We cannot permit our lives to waste away, our talents unchallenged. We cannot permit a failure to our duty. We are brave and we are boisterous, our mettle is proven, and we are dedicated.

The ground together: the ground of the American theatre on which I am proud to stand. . .the ground which our artistic ancestors purchased with their endeavors. . .with their pursuit of the American spirit and its ideals.

I believe in the American theatre. I believe in its power to inform about the human condition, I believe in its power to heal, "to hold the mirror as 'twere up to nature," to the truths we uncover, to the truths we wrestle from uncertain and sometimes unyielding realities. All of art is a search for ways of being, of living life more fully. We who are capable of those noble pursuits should challenge the melancholy and barbaric, to bring the light of angelic grace, peace, prosperity and the unencumbered pursuit of happiness to the ground on which we all stand. Thank you.

Name: _____

THE GROUND ON WHICH I STAND *by August Wilson*

Review Questions

1. In his article, Wilson states, "black playwrights everywhere remain indebted to [black playwrights of the 1960s] for their brave and courageous forays into an area that is marked with land mines and the shadows of snipers." What does he mean by this statement?

2. In his article, Wilson states, "theatre is part of art history in terms of its craft and dramaturgy, but it is part of social history in terms of how it is financed and governed." In context of the article, what does he mean by this statement?

3. Wilson discusses the concept of "colorblind casting." What is meant by this term? What is Wilson's position and what is your opinion about the notion of colorblind casting?

4. Wilson discusses the terms "artist of color" and "people of color." What is meant by these terms? What is Wilson's position vis a vis these terms and what is your reaction to them?

5. According to Wilson, the "subscription audience" serves to keep blacks out of the theatre. By his reasoning, how does it do this? Do you think he is right? Can this notion be applied to people of another category—youth, for example?

Research Topics

1. In his article, Wilson says that of the sixty-six LORT (League of Resident Theatres) Theatres, there is only one that can be considered black. Can you discover if now, ten years later, there are any more LORT theatres that can be considered black? Of those that are black theatres, what are their mission statements?

2. In the article, Wilson states that there are two distinct and parallel traditions in black art, one that is conceived and designed to entertain white society and the other that feeds the spirit and celebrates the life of black America. Identify examples of black art that fall into these two distinct traditions and describe how they fulfill the defining criteria of those traditions.

3. The author quotes Robert Brustein extensively from an article Brustein wrote for *The New Republic,* July 19–26, 1993, titled "Unity from Diversity." Find the article, read it, and discuss whether or nor Wilson's assertions about Brustein's opinions and positions are accurate.

4. Read a play by August Wilson and discuss how or if it reflects the voice and opinions expressed in this article.

5. In the article, Wilson identifies several black playwrights of the 1960s. Pick one and discuss that playwright's work.

6. Wilson discusses the notion of an all-black production of *Death of a Salesman*. Research whether or not such productions have taken place. Have there been productions of this play with casts completely composed of other races? How might these productions inhibit or enhance a race's sense of identity, history, and social value?

7. Who is W. E. B. DuBois, and what is meant by the "talented tenth"?